PIGEONS ON THE GRASS ALAS

PIGEONS ON THE GRASS ALAS

CONTEMPORARY CURATORS TALK ABOUT THE FIELD

With drawings by Sarah McEneaney

THE PEW CENTER FOR ARTS & HERITAGE, PHILADELPHIA

TABLE OF CONTENTS

FOREWORD

We at The Pew Center for Arts & Heritage like to believe that we are experts at convening experts. Almost weekly, we host thought leaders—including artists and cultural producers—from around the world at our headquarters in Philadelphia. They come to participate in roundtable discussions, run workshops, and meet with our grantees and other constituents in one-on-one consultations. They collaborate with us on research, helping us to identify and then analyze critical questions in the fields that we fund. They also adjudicate our grants—and are thus integral to the annual distribution through the Center of millions of dollars to support visionary projects from artists, organizations, independent curators, and presenters in our region.

This book is a convening of experts unlike any other we have organized. Why? Because the "convening" only takes place within its pages, rather than inside our own walls. We started by inviting professional curators—pigeons, as we affectionately designated them in homage to Gertrude Stein—from near and far to respond to an evolving list of questions about their approach to their work—a "pigeonnaire," if you will. Intentionally general, the pigeonnaire probed such topics as influences, daily practice, issues in the field, artist-curator relationships, and the curator's responsibility to society at large. Over the course of a year, the pigeons dropped by with their answers, and as they did, we summoned them to roost on the Center's website. When more than

forty had nested, we decided that it was time to capture the moment in an absorbing little pocket book.

But we had our own questions: Was there a way, we wondered, to rethink the presentation so that it would be a conversation rather than a series of individual interviews? Could we juxtapose, to provocative effect, answers reflecting distinct viewpoints? How could we construct a situation so that the reader might believe she is witness to a real-time dialogue as it unfolds?

We decided to organize the contents not by contributor but according to the questions we had asked in the pigeonnaires. We then strung the questions and answers together in a continuous narrative that reads something like the transcript of a large meeting, or, in pigeon-speak, a kit. In the end, we think grouping the responses around key issues provides a relatively accurate portrait of common ground and fissures in the field of curating now. The pigeons have all been most thoughtful and candid, and we, pigeon fanciers, are deeply grateful to them all.

PAULA MARINCOLA, EXECUTIVE DIRECTOR
PETER NESBETT, SENIOR SPECIALIST, EXHIBITIONS

THE PEW CENTER FOR ARTS & HERITAGE

CONTEMPORARY CURATORS
TALK ABOUT THE FIELD

PIGEON FANCIER *Good morning, everyone. I am, as you all recognize, a pigeon fancier, and I will be stewarding today's conversation. Before we start, I want to say how grateful I am that you are here. You are a busy lot—constantly shuffling back and forth between your homes and Kassel, New York, London, Paris, São Paulo, Los Angeles, Dubai, Singapore, and elsewhere. I want to thank you on behalf of those who will read this transcript for joining our temporary flock. I also want to thank our convener and sponsor, The Pew Center for Arts & Heritage, for hosting us all here in Philadelphia.*

The agenda of the day involves no formal presentations. I thought it would be more revealing— perhaps even more enjoyable—if we could just talk. So here is how things will unfold. I'll ask a series of questions to the entire group, and you can respond if you feel like you have something to say. I have a lot of questions. Do not feel compelled to respond each time. A few of you told me when you arrived that you have other commitments and will need to leave early. I'm

expecting a few others to drop by later. That's okay.
Our kit will evolve as we go through the day.

I'd like to start by asking all of you a formative
question. That is, what experience in your life
best prepared you for curatorial work, particularly
exhibition making?

ASTRIA SUPARAK A few years ago, I rediscovered a journal entry that
I wrote when I was six: "When I grow up I want to be a artist and
sintist [*sic*]." In retrospect, curating seems like a logical outcome of
concurrent interests in art making and science, which continue to
coalesce in the projects that I produce and organize. Also, I grew up
making art in a nonart family. And as a teen in Los Angeles, I became
interested in punk rock and Riot Grrrl, and in finding, creating, and
supporting alternatives to the mainstream. This has remained a core
part of my curatorial agenda: giving voice and space to marginalized
points of view.

SHANA BERGER My academic and studio training as an artist no doubt
provided me with a background for curating, and I continue to approach
curating as an artist.

RALPH RUGOFF Writing about art, including reviewing gallery and
museum exhibitions, was probably my best training because it involves
thinking carefully about works of art and how they are presented, as
well as fashioning arguments about the meanings of those artworks
and exhibitions and trying to understand their successes and failures. It
was through writing reviews that I first confronted and tried to think
through the curious phenomenon of how an exhibition with good art
could end up being a mediocre exhibition (and vice versa). At the same
time, looking at, thinking about, and writing about various exhibitions
and displays that aren't art but have distinct aesthetic aspects has also
been a very useful (and always interesting) experience. In any case,
having coming up that way myself, I suspect that I have a slight bias
toward shows organized by writer-curators in general. I like exhibitions
that articulate their premises clearly and imaginatively.

JENNIFER GROSS For me, it was being the director of a commercial art gallery for ten years at 420 West Broadway in New York City in the late eighties and nineties. Leo Castelli, Sonnabend, John Weber, and Charles Cowles galleries were all in the building, and it was an amazing education to see their programs up close. At Germans Van Eck, where I was, we worked with young and emerging artists. This gave me the privileged and humbling opportunity to observe artists' studio practices on a daily basis. We hung ten to twelve exhibitions a year, which was a really fantastic way to understand how important a respectful presentation/contextualization is for an artist's work. Every detail mattered. In my last few years at the gallery, I had the opportunity to curate a few thematic exhibitions, and that definitely whetted my appetite for curatorial practice.

LISA MELANDRI Two things from my childhood may have pointed the way for this career. The first is that my father is not only a collector but an arranger. His collections are mostly objects—early Americana—and he spent as much time figuring out how best to present them as he did amassing them. My childhood home had and still has a great number of discrete "exhibitions" that all work together to make a dynamic but simultaneously livable environment. Watching and sometimes taking part in that process was completely satisfying, even at a really young age. The second is that my mother introduced the museum to me earlier than I can actually remember. And I recall that she always made contextual and formal connections among objects and artists across periods and galleries—she had a kind of curatorial take on the encyclopedic museum!

CARLOS BASUALDO I came to the United States in 1992 when I was twenty-eight years old, and by that time my aspirations as a person determined to work in the field of culture were quite cemented. The Argentina in which I grew up was a highly discursive context that valued intellectual integrity, sophistication, and originality. Having said that, I believe that the determining encounter in my adult life was with the city of New York. It was a very different cultural and, specifically, working environment than the one I had experienced in Argentina. It was very difficult, tough. It

certainly added structure and discipline to the way in which I work and think.

PIGEON FANCIER *So how did you find your métier?*

CARLOS BASUALDO I started to curate because I felt curating was more effective than writing as a means of articulating my thoughts. I was mostly writing poetry in Argentina at that time, and I was suffering from the lack of a public, which is endemic to poetry. I imagined that as a curator I could have a public, and in my experience that assumption proved to be correct. I did not start curating with any agenda besides that of a strong desire to think alongside art and artists.

PIGEON FANCIER *Thank you, Carlos. That provides a natural segue to my next question: what influences outside the visual arts inspire and impact your approach to curating?*

ANDREA GROVER I usually have my attention tuned to digital culture, science, engineering, and design, and the writings of media theorists who anticipate where technology will ultimately take us. Authors like Nicholas Carr, Clay Shirky, Howard Rheingold, Douglas Rushkoff, and Sherry Turkle are among those I reach for first at the library. While artists tend to be the first to identify and exploit a new technology's unforeseen potential, these authors decipher what's happening in a societal context. I also have a soft spot for tales of global exploration, from early Amazon explorers like Percy Fawcett to polar voyagers like Ernest Shackleton. I find inspiration in the minds of those who seek the unknown.

NICHOLAS FRANK Musicians engage in practitioners' critique; that is, the makers respond to other makers, saying what's good by doing: copping, quoting, imitating, recognizing, and preserving. Artists work similarly;

how they respond to each other is a good guide for curation and criticism. I also like a certain kind of DJing that teases out and forces relationships across eras and styles, defying consistent thematics and finding conflicts, tensions, conciliations between differing intents.

In a more personal sense, the literary work of Paul Metcalf has been a big influence. Metcalf invented a form of novelistic text-collage wherein his authorial work is invisible but felt, palpable. He researches and stitches together diverse sources of original material to address a particular topic: locale, persona, event, or speculative reconsideration of history. He works with the work of others, his voice only resonating in the background through the research, editing, and arrangement of existing material—this is my curatorial ideal. But then, TV haunts me, at least those few instances of someone slyly doing good in the world under cover of doing something else. *Mary Hartman, Mary Hartman, The Larry Sanders Show, Generation Kill*: this is serious stuff.

DAN BYERS I'm often surprised that more visual-arts curators don't look to organizations and publications that regularly compile, mix, juxtapose, and integrate different kinds of content along thematic or historical guidelines. As someone who grew up listening to National Public Radio, that organization's more experimental programming has always seemed a good example. *This American Life, Radiolab, On the Media*: these are examples where content is king—and is kept intact and clear—and yet it is delivered through a decidedly subjective, educated, and experimental lens. And while radio is specifically suited to producing pathos through listening to stories and voices, I often wish that even our most reticent and contingent exhibitions could delve more honestly and bravely into those emotional realms. In addition to good radio, I think good examples are compilations of short stories, a range of counterculture magazines from the sixties and seventies that mixed very different cross-disciplinary offerings, albums that collect and mix rediscovered folk music from around the world (and reissues of classic, lost albums from small labels). All of these things are inspiring and opinionated, yet still respectful, platforms for presenting experimental culture.

When I'm thinking about curating our permanent collection at the Carnegie, I think about making my way through used bookstores

and the pleasure of discovery there. In the art context, this makes me want to include things that are not necessarily central to art history but might strike a chord for other, more associative reasons. Also, Top Ten lists are always fun. I think about these less for their promotional or canonizing potential and more for the form. It's nice to think about their restrictions and the necessity to animate difference and make a case within such narrow forums. Finally, the way artists collect and organize can be very inspirational.

CESAR GARCIA Recently, I have been inspired by spatial and architectural theory, dance, and body-based practices. I am interested in the way curatorial practice can extend beyond conventional notions of space and create its own ecological circumstances and spatialities in which to foster artistic projects. The central role of the body and notions of presence in a time of increased digital interaction are also of great interest to me, and I have been looking into the ways that dance, rhythm, and composition generate moments of engagement between bodies and spaces and how those moments can become opportunities for exhibition experiences.

JENIFER PAPARARO When I first started to define myself as a curator, I socialized on the periphery of a small group of poets in Toronto. I didn't participate much beyond that of being an audience member, but I managed to convince the gallery I was working for to host a few poetry readings at night. It was an academically oriented gathering of poets—the likes of Christian Bök, Peter Jaeger, Darren Wershler-Henry, and Jeff Derksen from Vancouver. The mentor of the group was the inexhaustible Steve McCaffery, who moved to Canada in the late sixties to work with the Concrete poet bpNichol, with whom he founded the Toronto Research Group. One of my favorite works by McCaffery is his aural translation of the Communist Manifesto in a heavy Yorkshire dialect. Another major influence on the group was the American poet Charles Bernstein. In the late nineties, I followed the poets to Buffalo to hear Bernstein read. I haven't retained any of the specifics from the poems he read that evening, but what resonates is Bernstein's charismatic demeanor, his humor, and the conversation that proceeded, which was about the relationship between visual art and

poetry. I remember articulating that I wasn't in favor of cross-pollinating the disciplines.

My camaraderie with the poets back then wasn't part of an effort to find a bridge between my discipline and theirs, but it stemmed from a fundamental interest in their process and product. I was fascinated by their seemingly constant and unending need to push the structural, constitutive conventions of language and the success with which they managed to topple something so familiar with the slightest of inferences. I believed they shook this familiarity with consequence, defying assumptions about how language operated and where meaning resided. I was also drawn to the more absurdist moments: Christian Bök reading Kurt Schwitters's Dada poems and Bök's performance of the alien language he wrote for some late-nineties science-fiction TV show.

CLAIRE TANCONS You're more likely to find me in Port of Spain, Trinidad and Tobago, for Carnival, in New Orleans at a second line, or in New York at an Occupy Wall Street demonstration than at the last biennial or fair—though I was just at the Hong Kong art fair, Manifesta 9, and Documenta 13. An important turning point in my practice was returning to the Caribbean—where I am originally from—in 2004 and rediscovering Carnival as a vibrant field of cultural production and artistic experimentation. Bringing myself up to speed about developments in this arena and attempting to trace its artistic lineages have led me to think more generally about public ceremonial culture as an underexamined field of creative endeavor, and to give visibility to it through curating, writing, and researching, all of which are inextricably linked in my work.

HELEN MOLESWORTH I think that first and foremost I am influenced by artists and their work; that combines with my interest in trying to place contemporary art within an art-historical framework. But I'm also aware that the world in general and what's happening in my life specifically exert a kind of unconscious pull. For instance, I started to work on an exhibition about the eighties in the wake of the current economic crisis because it seemed to me that the eighties were the years—economically, politically, and culturally—that set the stage for our current debates about the role of government in society.

PIGEON FANCIER *Hanru, what about you? Who and what are your primary influences? It looks like you have a list. Do you want to just read it?*

HOU HANRU Bada Shanren, Ni Zhan, Jin Nong, Huai Su, Yan Zhenqing, Gu Yanwu, Huang Yong Ping, Mao Zedong, Paul Cézanne, Piet Mondrian, Russian Constructivism, Bauhaus, Cubism, Dada, Joseph Beuys, Yves Klein, Happenings, Marin Varbanov, Michel Foucault, Roland Barthes, Jacques Derrida, Frantz Fanon, Edward Said, Homi K. Bhabha, Arjun Appadurai, Paul Feyerabend, Samuel Beckett, Bertolt Brecht, Guy Debord, Situationists, Rem Koolhaas, Constant, Merzbau by Kurt Schwitters, Cathédrale de Chartres, Notre Dame de Paris, la Basilique Sainte-Marie-Madeleine de Vézelay, Lindisfarne Gospels, Metabolism, Archigram, Led Zeppelin, Ludwig van Beethoven, Pink Floyd, David Bowie, Serge Gainsbourg, Cantopop by Sam Hui and George Lam, etc., Pearl River Delta as a social laboratory for the last two thousand years, the world of the 1980s, especially 1989 (with the avant-garde movement in China), "Magiciens de la terre," the events at Tiananmen Square, the fall of the Berlin Wall, the death of Ceauşescu, Pelé, Hakim Bey, Autonomia, Toni Negri, Frankfurt School, Ludwig Wittgenstein, *The Name of the Rose*, *Trainspotting*, *Pulp Fiction*, "informal economy" . . . and endless things related to utopia, chaos, and derision.

PIGEON FANCIER *I forgot to mention when we started that The Pew Center for Arts & Heritage has provided gourmet breadcrumbs and artisian puddle water. You can find them on the path near the bench.*
 All right, now where were we? Oh, yes, the next question is: from where do you get your exhibition ideas?

STUART HORODNER From the art I see and read about, creative legacies that fascinate me, and conditions in the world. For example, my upcoming

exhibition "Painters Panting" draws its inspiration from "Painters Painting," the 1973 documentary directed by Emile de Antonio examining American art movements from Abstract Expressionism to Pop. The purposeful misspelling of the exhibition title expresses something of its focus—the exasperation with and ongoing passion for "paint and process" by painters, photographers, filmmakers, and performers. It includes artists David Diao, Craig Drennen, Saul Fletcher, Alex Hubbard, Judy Ledgerwood, Chris Martin, and Jennifer West. I'm interviewing them all (plus critics, dealers, and collectors) for a remake of the film.

I've done thematic exhibitions that explored the act of walking, erotic drawing, and whether and how art could function as a pedagogical tool. These were chiefly prompted by noticing several artists whose works shared a similar focus. Sometimes projects are hatched through dialogue with colleagues, and I've enjoyed collaborating with other curators, including Regine Basha, Barry Blinderman, David Liss, and Saul Ostrow. This has allowed for the sharing of enthusiasm, skill sets, and institutional resources.

Solo exhibitions are often the result of following an artist and feeling that I might be able to work with them at a particular time and in a unique context. I'd say that my endeavors with Melanie Manchot, William Pope.L, Dana Schutz, and Laura Poitras are successful examples of this.

PIGEON FANCIER *Ruba, where do you get your ideas?*

RUBA KATRIB I'm not exactly sure. And by that I mean that it's very difficult to pinpoint an exact process for generating ideas. Many ideas come from conversations with artists, sometimes from seeing exhibitions and artworks, and sometimes from reading texts, seeing films, etc. I try to maintain an active practice of looking, listening, and hoping that things will fall into place, click, or collide at the right moment. When ideas and artists come together I have a starting point. I think that's when the most productive idea formation and research process happens. Making the commitment to develop the slightest flicker of an idea

is when things start to take shape. And usually the end result is very different from the starting point. For the most part, I think the act of exhibition making is about getting a dialogue started, actively following it through, and being receptive along the way.

PAUL SCHIMMEL Most of my ideas come from working directly with artists. I have also found that one show often leads to another. For example, the exhibition "Destroy the Picture: Painting the Void, 1949–1962" very much stemmed from the 1998 exhibition "Out of Actions: Between Performance and the Object, 1949–1979." Even with historical exhibitions, it is really about what is relevant to artists today and trying to view historical figures through the directions and interests of artists working today.

MAI ABU ELDAHAB There are two different types of situations: one in which the exhibition is built in response to a context and the second in which the venue or frame is so clearly defined as a place for contemporary art that the exhibition doesn't need to dialogue with more than its own field. A good example of a context-specific project would be the exhibition "A Fantasy for Allan Kaprow," which I cocurated with Philippe Pirotte in Cairo in 2009. With an increasing interest in performance among local artists, the absence of possibilities of viewing historical work, and few exhibitions built around new commissions, an exhibition around the work of Allan Kaprow seemed an exciting project for that location. By contrast, when I was director of Objectif Exhibitions in Antwerp, I focused on producing solo shows based on my own artistic interests, without consideration of context beyond the particularities of my institution.

Generally speaking, I am not a proponent of group exhibitions outside of museums and large spaces where long periods of dedicated research are possible. In all cases, it is the work of interesting artists with unique worldviews and languages that is my main source of ideas in terms of exhibitions.

NAMITA GUPTA WIGGERS Research is a constant, ongoing practice. Archives—particularly those that we've been trained as art historians to employ—do not necessarily contain the documentation and

information that I need to fully examine craft and design of the past seventy-five years. To stay current—and to develop new approaches—I spend time talking to and visiting with artists, art historians, and curators; I visit people, places, and studios in the Pacific Northwest and every place to which I have the chance to travel; I explore the likely suspects of the contemporary-art, craft, and design worlds (magazines, E-flux, websites); media-specific sites (Klimt02, Crafthaus, Ceramics Now); and social media (Twitter, Facebook, Critical Craft Forum, Tumblr, Pinterest), and I basically approach every environment and encounter as a potential opportunity to rethink curatorial practice. My iPhone, laptop, and iPad are the most productive tools to access people, images, and discourse and to prompt conversations that lead to curatorial projects. These allow me to reach anyone anywhere and to see things that I would have no access to through print publications and print media.

I watch my local communities closely—paying attention to what people are making and thinking about—and work to connect local questions to broader issues surfacing across national and international platforms. My efforts are to work locally and globally at the same time. Every conversation is an opportunity to understand the world in a new, fresh way.

When working in craft and design, the spaces between—and opportunities to integrate—the "white tent," "white cube," and "white page" are infinitely productive.

PIGEON FANCIER *With this next question, I'm going to reveal my own homing instincts as an art historian. What singular experience, circumstance, or environmental consideration over the past decade has most profoundly impacted the way you work? Sean and Fiona, do you want to address this?*

SEAN DOCKRAY AND FIONA WHITTON The housing and art-market bubbles had the effect of nearly doubling our rent in the span of a year. It was clear that our time was limited, and so we wanted to squeeze everything out

of that space that we could, and it was during this time that we started the Public School.

By then we'd also moved our program toward more music, performances, and screenings, and we generally focused on bringing in artists who worked in public or who used the exhibition space as a productive site rather than a terminus. Eventually, our time ran out, and we couldn't keep up with the rent anymore, so we moved the school into a cheaper basement and got rid of our physical gallery space entirely. It was almost as if our hands were tied, clutching onto that space, and when it was finally pulled away there were new possibilities. We immediately started a video project called the Distributed Gallery with several other small businesses in the neighborhood (Fong, Ooga Booga, and Via Café), as well as a fictional gallery in Berlin, which was experienced exclusively through publicity and media. And since then, the Public School has become an international project, with groups of people in ten cities organizing classes.

PIGEON FANCIER *How about people in the field who you look up to? Whose curatorial practice has inspired your own work?*

JENS HOFFMANN If I were pressed to name names, I would say that Hans Ulrich Obrist, Okwui Enwezor, and Ydessa Hendeles have been very important to my thinking around exhibition making: Hans Ulrich for his early out-of-the-box ideas such as "Do It" or "Laboratorium," Okwui for the simultaneity of his intellectual rigor and poetic sensibility, and Ydessa for her incredible installations and eccentric juxtapositions of artworks and cultural objects.

VALERIE CASSEL OLIVER There have been so many sources of inspiration that this question is a very difficult one to answer. In truth, I have been deeply influenced by pioneers like Lucy Lippard, Linda Goode Bryant, Samella Lewis, Deborah Willis, Leslie King-Hammond, Lowry Stokes Sims, Jeanette Ingberman, and Thelma Golden, among others. They are true intellectuals—modern-day philosophers who have reconfigured

how we think about art and the people who create art and why they create. They have also understood, instinctively, that art is a component of a much larger history and existence.

GLENN ADAMSON I've had a change of mind about this. Until recently, my models of curating were people like Ralph Rugoff [nods and smiles at Ralph], whose exhibition "The Painting of Modern Life" at the Hayward Gallery was as drum tight a show as I ever remember seeing— or further back, Rudi Fuchs, whose crystal-clear summer show of 1983 (anchored by the works of Daniel Buren) was re-created with loving care by the Van Abbemuseum in Eindhoven, the Netherlands, in 2009. I think if you work in design and craft, like I do, you tend to yearn for intellectual respectability. One way to get that credibility is to array a group of works according to a deep and complex idea.

But more recently, I have begun to embrace a looser, more evocative, art-like approach to curating. I have been thinking of exhibitions more in terms of space and affect, as an art-like practice. Some artists do operate according to a tight, conceptual methodology— examples of this would be Mark Wallinger, with his "Russian Linesman" show (also at the Hayward), and Simon Starling, with his project "Never the Same River (Possible Futures, Probable Pasts)" at the Camden Arts Centre. I've just done a show at the commercial gallery Bischoff/Weiss, called "Chain, Chain, Chain," which was about contemporary commodity sculpture and aspired to a similarly cerebral approach.

Recently, I was very taken by Grayson Perry's show at the British Museum, "Tomb of the Unknown Craftsman." This was a much more permissive project, maybe arbitrary and limited in its intellectual ambitions but infused with feeling and personality. It made me think that Perry is actually a better curator than an artist, and even that the things I do like about his art are rather curatorial in character (the choices he makes, rather than the things he makes, if you see what I mean). Of course, Perry is operating in the craft terrain, so the exhibition spoke to me for that reason, too. Partly as a result of that experience, I have been feeling as though I want to work more from the heart and less from the head. Maybe it's just the mood I am in at the moment—I want to convey a more personal, emotional sense

to the audience and am less worried about communicating an effect of intelligence per se.

RITA GONZALEZ My education was incredibly interdisciplinary, and I got into curating after studying to be an artist. After my MFA, I went to the University of California, Los Angeles's critical studies doctoral program in the School of Theater, Film, and Television to work with Chon Noriega and Peter Wollen. I was interested in how both film scholars approached art history and exhibition curating from a passionate position—less caught up in institutional, disciplinary, or market concerns, since they were to a certain extent interlopers.

Wollen's teaching and curatorial style was driven by what I think of as passionate information. He was often speaking of "being there" (either directly in a room with an artist or filmmaker or from the vantage point of a direct experience of an era). Noriega's curating was and is more about advocacy, accountability, and representation.

PIGEON FANCIER *What about you, Paul? Who has inspired you?*

PAUL SCHIMMEL James Harithas, former director of the Everson Museum of Art, the Corcoran Gallery of Art, and the Contemporary Arts Museum, Houston, and current director of the Station Museum of Contemporary Art in Houston. He taught me that the artist has the first, middle, and last word. If you love them and put your job and your life on the line with them, then they will do great things.

NATO THOMPSON Strangely enough, I must say that one of the first exhibitions to truly turn my head was your [points to Paul] "Out of Actions." Being introduced to such profoundly aggressive work as Viennese Actionism, Gutai, Chris Burden, Yoko Ono, Allan Kaprow, and Lygia Clark blew my mind. I had not considered art in this way before. But the work in this exhibition contained such a radical approach to performance and, more than anything, an everyday experience of being in the world. I was in my early twenties at that

point and had never considered the idea of being a curator. It wasn't until graduate school that I even remotely considered this field a vocation.

In graduate school, I experienced the exhibitions and projects of the collective Temporary Services. They were extremely important in my thinking. Heavily influenced by the work of many Scandinavian utopians like N55 and Superflex, Temporary Services introduced me to the exhibition as a way of thinking through the world. They managed to include the insane and the political, the international and the deeply local. They had a profoundly ethical practice that was still strange and beautiful.

Okwui Enwezor's Documenta 11 also radically shifted my conception of what was possible in the arts. Perhaps on the furthest end of the spectrum from the project-space approach of Temporary Services, Enwezor took seriously the proposition that art, particularly in the documentary vein, could shift the landscape of politics itself. Using the platform of Documenta, he invited some of the world's greatest minds to weigh in on some of the world's most pressing issues. It made a large impression on me.

There are many curators at this point to whom I pay attention. It is sort of split between formal curators and artist collectives that put together projects. Here is a short list for the fun of it: everything Sina Najafi and crew do at *Cabinet* magazine; the goings-on at Mildred's Lane; the projects, journals, and exhibitions by the great collective E-flux (Anton Vidokle, Julieta Aranda, and Brian Kuan Wood); the entire Occupy movement; Philly's own Basekamp—in particular, the Plausible Artworlds project; Charles Esche, Maria Lind; Chus Martínez; Jens Hoffmann; Ralph Rugoff; Sofía Hernández Chong Cuy; my ol' colleague Mark Beasley (a great curator); the experiments and levity of Joseph del Pesco; just recently, the people at Weeksville Heritage Center; the awesome constant rethinking of Kate Fowle at Independent Curators International; at times, the experimental approach of Hans Ulrich Obrist (the man has so much energy); the education programs at the Walker and the Hammer; the projects of Christine Tohmé at Ashkal Alwan in Beirut; the work of Fulya Erdemci and Theo Tegelaers at SKOR; the writings of Sue Bell Yank, Shannon Jackson, Gregory Sholette, Yates McKee,

Jaleh Mansoor, Boris Groys (though I don't usually agree with him), and Claire Bishop (though I don't agree often with her either, ha-ha).

INGRID SCHAFFNER I was lucky to take a graduate-school seminar on "fine-art cataloguing" with the art historian Angelica Rudenstine around the time that she was the consulting curator for the National Gallery's Kazimir Malevich exhibition; her exacting scholarship set a standard of curatorial connoisseurship that remains a formidable model. Also inspirational was Richard Martin, whose creative intellect and critical imagination virtually vibrated the air of every exhibition that he synthesized from art, fashion, words, and ideas; his installations were exquisite objects in their own right.

Finally, I have an endless appetite and appreciation for artists as curators. To name just a few inspiring examples: Douglas Blau, Robert Gober, Joseph Kosuth, Virgil Marti, Josiah McElheny, Elizabeth Murray, Beverly Semmes, Jessica Stockholder, Kara Walker, and Fred Wilson have all shown, in extremely varied ways, that, as long as a curator trusts and cares deeply enough about the objects he or she is presenting, no exhibition can be too idiosyncratic.

MARK BEASLEY The London-based artist collective BANK is relatively unknown in the US but something of an inspiration for a generation of artist-curators in the UK. From 1991 to 2000, they organized every conceivable form of exhibition. The exhibition titles alone bear repeating: "Zombie Golf," "You Hate Us Because We're Working Class," "Stop Short-Changing Us: Popular Culture Is for Idiots. We Believe in Art!" They also published the *Bank*, a broadsheet that, as Art and Language had previously done, provided critical relations with their times, prefiguring and commenting on that moment in time when art—its study and its handling—became a "lifestyle" choice, from the rise and professionalization of curators to out-and-out hilarious and dumb headlines such as "Galleries 'All Owned By Rich People' Shock" and "Gillian Wearing Thin." It's inconceivable that any emergent force today would be allowed or willing to put themselves on the line to the extent they did.

Two other figures that I and many others are indebted to: the first, Malcolm McLaren. His various stores on King's Road, from Sex

to the Nostalgia of Mud, are provocative models when one thinks about audience and the presentation of complex ideas unwilling to go quietly—Nostalgia, the store with no floor, was just a muddy basement hung with clothes, but it was frequented by one Diana Spencer and the Debs and Sloanes of King's Road. The image alone is compelling. One of the pluses in moving from London to New York was to meet and know something of Malcolm.

The second is Mike Kelley. In 2009, I worked with Mike and cocurated with him the music festival "A Fantastic World Superimposed on Reality" for the Performa biennial. The selection and discussion of what works and musicians to include was an insight into experimental music, as well as into a methodology and a mind that traveled through many forms. Mike's writing, exhibitions, and artworks, from *Foul Perfection* to "A Fantastic World," are all experiments in how to engage in one's time and to attack lazy thinking. There are essays of his that I read again and again. What isn't so easy to state or pin on history is the wit and humor that Malcolm, Mike, and BANK deployed. My enduring image of "A Fantastic World" is of Mike throwing potatoes across a stage when presenting Rodney Graham's *Lobbing Potatoes at a Gong*. The studied deliberation with which he set about his task and the satisfying smack of the gong gloriously underlined an intensely serious and willfully satiric mind. The potatoes were later made into potato salad, which was passed among the crowd.

There are many more, but we all have things to do, right?

PIGEON FANCIER *We've got time. Let's stay with this question. Anne, do you want to jump in?*

ANNE BARLOW The experimental and risk-taking work of New York's alternative art spaces—many of which profiled emerging practices and ideas with a seriousness and rigor usually associated with larger institutions—was inspirational early in my career and brought me from Glasgow to New York's New Museum in 1999. As curator of education and media programs there, I looked closely at European and international projects dealing with collaboration, networks, and new

forms of engagement while developing Museum as Hub, a new hybrid program devised to connect the museum and its audiences to global arts issues in a timely and meaningful way.

From 2004 to 2006, numerous curators and thinkers—not just in the visual arts but also in the fields of design, architecture, publishing, and new media—took part in seminars on potential conceptual and structural models for this initiative. These discussions were some of the most interesting I have taken part in, as they went beyond the usual visual-arts frameworks and opened up our thinking process about what the program could be.

More recently, the approaches that were among the most resonant to me while working on the Bucharest Biennale and thinking about the history of various biennial models were those of What, How and for Whom/WHW's 2009 Istanbul Biennial (particularly the smaller sites) and Suzanne Cotter, Rasha Salti, and Haig Aivazian's 2011 Sharjah Biennial. Both of these explored relationships between art, politics, place, and agency in powerful ways that were multifaceted, at times controversial but also very incisive. While the Bucharest Biennale is vastly different in terms of its budget and scope, questions around the goals and impact of the biennale and how artists' projects relate to sites in the city, as well the public domain, were important preoccupations for me.

MAI ABU ELDAHAB I am more familiar with and relate more to artists and curators of my own generation, as they are the core community with whom I am in dialogue. I find inspiring curators who are deeply passionate about art and meticulous in their understanding of artistic practice, like Giovanni Carmine, Larissa Harris, and Victoria Noorthoorn. On the other hand, I am also interested in practices that are playful and situate art in the broader world of culture, such as those exemplified by Raimundas Malašauskas and Frédérique Bergholtz. Both these types of curators tend to be very close with artists they work with, find pleasure in art, value communicating to audiences, and appreciate their position as mediators of inspiring ideas.

JOSEPH DEL PESCO A number of curators have been influential in my thinking, starting with Richard Flood, Philippe Vergne, and

Douglas Fogle, who were at the Walker Art Center when I lived in Minneapolis, and later Ralph Rugoff [coos at Ralph to much laughter], Renny Pritikin, Matthew Higgs, and Kate Fowle, who were teaching at California College of the Arts (CCA) when I studied curatorial practice. Following school, Sylvie Gilbert and, later, Kitty Scott at the Banff Centre. And finally, Benjamin Weil and Raimundas Malašauskas, whom I worked with at Artists Space.

ARAM MOSHAYEDI My curatorial work is indebted to art historians: Norman Bryson, who taught me how to look; Richard Meyer, who taught me how to research; and Karen Lang, who taught me how to write. Also, Daniel Buren's early writings on the studio inform the way I approach artists and the privilege of access afforded by curating. My interest in these texts has as much to do with a type of thinking and research that happens in the moments that precede an exhibition as it does with Buren's concerns with physical space and the shape of production.

NAMITA GUPTA WIGGERS A number of people have inspired me, mostly because they've been willing to be audacious and embrace shifts in artistic practice—that is, cleared spaces for new approaches to emerge. It's not a surprising list—Marcia Tucker, Walter Hopps, Hans Ulrich Obrist, Helen Molesworth, Andrew Blauvelt. However, my inspiration for my personal curatorial practice is only partially drawn from these individuals and from what we understand to be the "field" itself. To curate, to help communicate the breadth and range of the subjects of craft and design today requires expansion beyond the contemporary-art arena and the museum communities in which training is focused. As a result, I frequently employ strategies, methods, and working philosophies drawn from other places—perhaps working more as a visual or cultural anthropologist.

Arjun Appadurai, the noted anthropologist, taught me approaches to cultural inquiry that permit me to move between center and periphery, to create dialogue, to recognize and employ power and structures, and to bring the margins into view. This is particularly useful when curating craft and design within a museum setting derived from the "white cube." I find that redefining the limits of the white cube is more

intriguing, as the museum is redefined in the twenty-first century, than perpetuating traditional modes of display. Having been trained in museum practices and as an art historian, I work to turn things inside out and upside down from within, thereby bridging practice as it has been with practice as possibility.

My years as a museum educator and researcher for e-Lab bring questions of user experience into what I consider to be the parameters of curatorial practice today. From Rick Robinson, design anthropologist and cofounder of e-Lab, I learned to apply my academic training to study interactions between people, objects, and environments. This expands the notion of curating to include programming, scenography, and experience—building audience and space into the concept of an exhibition project from the outset.

PIGEON FANCIER *Peter, then Sarah . . .*

PETER ELEEY I have probably been most inspired by individual artists, which I realize is cheating because they aren't curators, but it is true. Some of those who have been among the most inspirational share a kind of specificity, promiscuity, and awareness that I aspire to: among them, Darren Bader, Trisha Donnelly, Thomas Hirschhorn, Goshka Macuga, Mark Manders, Mike Nelson, and Sturtevant. They have given me specific advice or have provided models in their own shows—not simply those we have done together. But they all insist on getting away with more than they "should." As for curators, I realize I tend to be more inspired by specific shows than by the people who did them, but the curators I have been lucky to work closely with over the years have taught me a lot about ways to think, work, and behave, both on and off the field.

SARAH ROBAYO SHERIDAN Through my graduate studies at CCA, I was fortunate to have access to an eclectic range of visiting curators. Every week seemed to offer a new and wildly different model of working—from the enigmatic pseudomysticism of independent curator Raimundas Malašauskas to the curatorial auteurism promoted by

you, Jens, at the CCA Wattis Institute for Contemporary Arts, to the exemplary research and scholarship of Connie Lewallen at the Berkeley Art Museum. All this variety was very stimulating, but my most sustained mentor proved to be Steven Leiber, guru of artists' books and ephemera and professor at CCA. Steven approached the larger questions of art by studying what others might deem minor elements. He would never let you off the hook on any claim about art, would cut straight to the meat of a matter, and was gifted with an intuitive ability to connect with an artist's intent. His dogged attention to detail and his genuine passion for his field continue to influence and inspire my work.

PIGEON FANCIER *Have you seen an exhibition in the past five years that you thought was ahead of its time?*

ERIC FREDERICKSEN Sir John Soane's Museum, London, of 1837. The picture gallery and the Monk's Yard have inspired a lot of artists, architects, writers, and curators, but I'm pretty sure there are still good ideas left to rip off.

PIGEON FANCIER *That's way ahead of its time. What else?*

DANIELA PÉREZ Raimundas Malašauskas's "Hypnotic Show," ongoing since 2008 and by now presented in different venues, is not a project that I would necessarily describe as "ahead of its time" but perhaps is a project that is, in a way, timeless and current in different contexts. For the "Hypnotic Show," Raimundas commissioned artists to create immaterial works that the viewer, under the state of hypnosis, experiences as if they were tangible; many contributions take the form of descriptive texts or instructions for encounters with works of art. The hypnotized are usually volunteers that are part of an intimate group that has gathered in a space along with the curator and the hypnotist.

DANIEL FULLER An honest answer to this is no. Typically the exhibitions that I most think of as transcendent—Hans Haacke's "May 1, 1971," "Places with a Past," David Hammons at Knobkerry, "Thrift Store Paintings," Martha Rosler's "If You Lived Here: The City in Art, Theory, and Social Activism," and others—happened long before five years ago. However, I have come to prefer artistic and curatorial projects that do not conform to a perfectly timed beginning and end, such as Mildred's Lane, the Center for Land Use Interpretation, Machine Project, and numerous experimental art schools: Unitednationsplaza—Night School, School of Missing Studies, and Mountain School of Arts.

PABLO HELGUERA I believe the X Initiative, which was housed at the old Dia building on 22nd Street in New York between 2009 and 2010. Its approach was to take the exhibition as less of a preconstructed entity with an articulated thesis, a beginning and an end, than as an idea of the exhibition as a language that evolved like a conversation. It is not a model that works for everything, but over the last few years this has become a more generalized direction of experimentation for all sorts of spaces.

> PIGEON FANCIER *Has anyone else seen any exhibitions recently that were ahead of their time?*

SARAH ROBAYO SHERIDAN No, but I can think of one that is magically outside of time: the Museum of Jurassic Technology.

> PIGEON FANCIER *The eighth wonder of the ancient world. Agreed. I'd like to turn the conversation away from influences and to the question of audience. We all curate for someone. For whom do you curate?*

SHANA BERGER I curate for myself and my own interests, as well as for the other artists I work with, for a local audience engaged in participation, and hopefully for a broader audience not defined by geography or even discipline. I'm really interested in the dynamics of these multiple constituencies. Projects grow out of the common interests of these groups, which bring varied interpretations and viewpoints to the work. When each group is relevant to the work, we succeed.

NICHOLAS FRANK A friend and colleague, the experimental filmmaker Stephanie Barber, says that she makes films for an ideal audience, the person who will eagerly soak up every detail, lovingly caress every nuance, ponder every intellectual stimulus, and carry the film around inside them afterward. I suppose that describes my ideal audience as well. While pointing out that the audience for experimental film was something like two hundred people worldwide (mostly filmmakers), Barber used to organize the Outdoor Experimental Film Festival in a public park in downtown Milwaukee, where a family could bring a picnic to sit and watch twelve minutes of all-brown, lobster-scratched film (*What the Water Said* [1998] by David Gatten) and a couple hours of equally challenging stuff. Yet the event managed to consistently attract hundreds of viewers from across the whole spectrum of the city.

SEAN DOCKRAY AND FIONA WHITTON At first we were surprised at the idea that a curator possesses an audience, but today everyone has an audience. And even those people in the audience each have audiences, at least within their immediate social networks. There are asymmetries, to be sure. Certain people broadcast more than they receive, but the idea of audience has nonetheless become something much more fluid, with different possibilities and different forms of participation, passivity, engagement, and distraction than before. Perhaps what is most striking is that various audiences (and the cultural objects around which they circulate) aren't distinct and easy to recognize; rather, they are increasingly entangled, observant of one another, influential on one another's behavior, and so on.

We aren't particularly interested in expertly arranging artworks, being tastemakers, or making arguments about whether something is or isn't art. Instead, we focus more on things like how people make

use of a project, what types of activity its structure affords, and how it operates in the world over time (often much longer than an exhibition). Structures of audience necessarily become part of the structure of the project, certainly not separated by some fourth wall. Maybe this is where responsibility enters into it—to make those structures of spectatorship and interaction part of the projects, not taken for granted.

> PIGEON FANCIER *Ingrid, what about you—for whom do you curate?*

INGRID SCHAFFNER Is this a trick question? Curators have to be attentive to their audiences. Artists may be responsible only to themselves—to make something as well as they can so that it clearly expresses their ideas, interests, and passions. But a curator's responsibility is triangulated between an artist, the work of art, and an audience. You represent artists by allowing their work to speak for itself, at the same time you have to give viewers some sense of context, relevance, particularity, or essence that will enable them to hear what the work has to say. It's a delicate business and sometimes space is all that's needed for this transmission to take place. That's your call to make as a curator.

I keep a pocket audience in mind. It consists of a colleague I respect (someone who thinks about art in different ways than I do), a family member I love (someone who couldn't care less about art except they care that I do), and the artist (of course). Remembering to count one's self as an audience member is a good way to stay true to your own passions, interests, and ideas.

CLAIRE TANCONS As to for whom do I curate, it always depends and I never know. This is not a provocation. I think that my responsibility as a curator is not to force a particular viewpoint and hold captive an audience in the prescribed frames of knowledge institutions, such as the museum, the library, the archives . . . I am often surprised by the self-righteousness of so-called audience outreach, which seems to imply that this special category of culture known as the arts, often the visual arts indeed, holds a premium on knowledge and education. But who says

that we *should* go to a football game, attend Mardi Gras, or sit through the Angola Prison Rodeo?

Having curated public processional performances, I find that their audiences, and certainly their participants, are likely to have been wider and more diverse than the average museum- or even biennial-going crowd. But my intentions are not toward a "democratic demographic," if you will, but are toward a self-constituted collective of a variety of voices, however small and temporary it might be.

DAN BYERS I curate for a collection of audiences. Honestly. Here are some of them: I curate for me (what shows would I want to see?). I curate for artists and other curators. I curate for curious people. I curate for people who love some other field or subject the same way I love art. I curate for those people who need to be won over but are willing.

DANIEL FULLER First and foremost, I curate for myself. I work with art and artists that give me a charge, and the hope is that others are equally affected and inspired. Also, I have a tremendous responsibility to present the students of the Maine College of Art with new ideas and to reflect a worldly viewpoint. We are the only institution in our state whose mission is to present national and international contemporary art; as a result, we are committed to working with cross-disciplinary artists in hopes of opening worlds and possibilities.

Lastly, I curate for the general, perhaps uninitiated public. As someone who did not step into an art museum before the age of twenty, I approach many projects from the perspective of a storytelling enthusiast hoping to initiate meaningful conversations without taking an "a-u-t-h-o-r-i-t-a-r-i-a-n" tone. I wholeheartedly believe in increasing access to art. This frequently plays out with projects that go beyond the gallery, such as ICATV on Portland, Maine's public-access channel or bringing video art to the Jumbotron of the local minor-league hockey team. This is also why we so admittedly promote that the Institute of Contemporary Art at MECA is always free.

PIGEON FANCIER *Joseph?*

JOSEPH DEL PESCO I'm interested in thinking about, but not acting on behalf of, multiple or overlapping publics. We certainly see a braiding of parallel communities at Kadist in San Francisco. I think of the art world as a cluster of related subcultures, but we collectively (and I'm no exception) suffer from a cultural imaginary that art is relevant to a broader culture, even forming some of its root structure. I find myself aligned with an idea borrowed from Jean-Paul Sartre: that the "most challenging and productive exercise is to write for two widely different audiences simultaneously."

JENIFER PAPARARO For whom do I curate? I want to say my mother, more for comic effect than actuality. I don't want to perpetuate the cliché of "I present art in a manner my mother can understand." It is too condescending, yet in earnest I would like to engage her with contemporary art, and I try, though she generally isn't interested. She has told me on more than one occasion that the art world has an exaggerated sense of its self-importance. I usually laugh at this quip; there is some truth to it, but her dismissal and lack of desire to engage is a serious concern and a struggle that I mostly ignore. I'm not in pursuit of a resistant audience.

A better place to start would be for me to address my relationship to artists, whom I perceive as an audience. This symbiotic relation is one that shifts depending on varied parameters, but in general terms I see my position as both responsive and generative. As a curator, I have a bifurcated practice. I work as a curator at the Contemporary Art Gallery in Vancouver, a noncollecting public institution, as well as part of the curatorial and artist collective Instant Coffee.

My role in the latter was born as an attempt to enliven the relationship between artist and audience. It was sparked by noticing the difference between experiencing an artwork in the studio versus seeing it in an exhibition. Far too often, there seemed to be a loss of energy, or at least the terms of engagement were reduced. I think this occurs for varied reasons. The most obvious is the direct presence of the artist, but there is also the informal nature of the studio and the unfinished state of the work. The impetus for most of Instant Coffee's early event-based activities was focused on bringing these three circumstances together as public occurrences. We held large events, featuring work by

sometimes more than seventy-five artists, designers, writers, curators, and architects. The events were more like gatherings for which we were attempting to level artist and producer with audience—where artists could show their contributions to other artists. It's not like there weren't audience members outside of the artists, but we lessened the immediate divide.

Ideally, in both roles I want to build long-term relationships with artists, getting to know their work in-depth, as well as sharing my own interests and concerns with them. I believe this builds a platform from which we eventually respond to each other. Artists inform what I do, and the choices I make inform them. In part, I see my relationship with artists as part of building a dedicated audience. If I listen and respond to their thoughts and ideas, then inversely artists listen to my interests. We build an extended conversation.

Ironically, this is the easy part of building an audience. The difficulty is expanding it beyond such an insular and circular forum. I've been wondering lately whether the same formula for building relations between artist and curator can apply on a larger scale, between institution and audience.

Like the artist's interests, the audience's should always be considered. The goal of an exhibition should be generative and, of course, responsive to audiences. Reception is part and parcel of any exhibition. But I stumble in my argument already as basic questions arise. What does this audience look like? How do we know their interests? And why are they coming to experience contemporary art?

If we start with the latter question but direct it to artists, then we have a more tenable question, still difficult, but one to which I'm more confident responding. My aligning of artist and audience isn't to put them on equal footing. The artist will almost always play a greater role in that equation, but the audience is central in the creative process and they need to be informed of their integral role. This revelation seems a plausible place to start.

PIGEON FANCIER *What common thread unites the exhibitions you've organized? Do you have an*

*overarching agenda, or do you consistently employ
a certain methodology?*

ASTRIA SUPARAK My practice has had really distinct phases, based on
the contexts, audiences, and my interests at those times. I fell into
curating as an art student at Pratt Institute in Brooklyn, where in my
spare time I ran a weekly media series that became part of a new wave
of experimental film and video art in the late nineties. Early on, curating
offered a platform from which to learn about disciplines and subjects
outside of my classes and provided a means to bring together diverse
communities into one room. After graduating, I became an itinerant,
independent curator for microcinemas, festivals, art institutions,
bands, and unconventional spaces from sports bars to skating rinks
to ferry boats. Those film and video programs (often with music and
live performance elements) were a direct outgrowth of my art making,
assembled mainly by intuition, a more abstract and poetic style of
curating that was reflective of the cultural moment and included a lot of
artists from my generation from the margins or outside of the art world
at the time. Those shows were less about illustrating preconceived ideas
than about creating an emotional resonance and a narrative arc.

 Then, in my midtwenties, I was hired to be the inaugural director
of a new university gallery in upstate New York, which was the first
time I worked with a consistent exhibition space. Despite having a
conventional white cube at my disposal, I resisted traditional exhibition-
making approaches, transposing the strategies that I developed as a film
and video curator to the space of the gallery: namely, the idea of making
intuitive and ethereal connections between works rather than selecting
pieces that would demonstrate a specific thesis; emphasizing group
exhibitions rather than solo shows; incorporating nonart and highly
local elements; and involving visitors in dynamic and unpredictable ways.

 Now at the contemporary art gallery of Carnegie Mellon
University, and with increased interest in appealing across campus
and city, my programming covers a broad range of subjects, recently
including urban planning, science and technology, hacking, social
justice, geography, economics and labor, alternative histories, and sports-
fan culture. Since Pittsburgh houses many established art institutions,

I wanted to create a clear and distinct identity for the gallery. We've done that in a short period of time with programming that is more explicitly social and political. Throughout all of this, what has remained consistent is my belief that curating provides an opportunity to explore ideas in surprising ways; to create memorable experiences; to support artists and politics I feel passionate about; to showcase unique and underrepresented perspectives; and to bring different people, from various walks of life, together.

DANIELA PÉREZ I don't believe that I have yet a visible or evident common thread throughout the projects I have developed. I am still learning a lot about my personal take on a curatorial practice that does not make strict divisions between the forms of involvement in projects. However, I do recognize a personal interest, or at least a recurrent one, in working with conceptual artistic practices that delve into blank spaces from a historic and fictional point of view, at times addressing binary terms like memory and oblivion, empty and full, construction and destruction, relevance and extraneousness, position and displacement, among others.

I am also interested in diverse formats that address specific content through temporary gestures and strategically conceiving projects in different sites and venues following methodologies that can address these things simultaneously. Part of my current "agenda" is to privilege these kinds of projects through the curatorial platform I have recently started.

RALPH RUGOFF The only overarching agenda that comes to mind is a desire to make exhibitions that can engage people on multiple levels, that can be experienced viscerally as well as intellectually, and that are serious and also playful. Part of my definition of a successful exhibition is one that confuses a little but doesn't leave the viewer feeling excluded. I'm not sure this is a common thread, but I always hope to curate shows that allow people to entertain some uncertainty about the nature of what they're seeing, its value and worth, as well as its possible meanings, and what rules and criteria we "should" be using to examine it. Sometimes it's possible to do this in a show that makes a specific argument linking a group of artists and illuminating their work differently—that goes against or around the grain of conventional ways of thinking about that

work and what it means historically. Other times, it might be a matter of just spotlighting current artistic activity that opens up intriguing questions around a particular area.

In general, I think the best shows I've done are probably the ones whose roots are tied up with some kind of personal obsession or that grow out of my own experiences and responses. I think working that way is more difficult in institutional settings, and may be one reason why so much high-level museum curating feels largely academic to me.

PIGEON FANCIER *Hi, Aram, thanks for stopping by. We are talking about the common threads that join our various exhibitions. Can you identify any in your work?*

ARAM MOSHAYEDI Rather than working with art objects, I've tended to work with artists directly on the production of new projects. My interests are much more to do with the processes by which things come into being, and this makes it harder to identify themes or narratives that have informed my practice to date. Maybe it's something more like curating personalities, or trying to find like-minded individuals who are comfortable working within the specific set of conditions imposed by a given context. Exhibitions are merely devices of mediation, not unlike other cultural forms or information technologies that create distance between subjectivities and lived experience; this is something I'm trying to work against, with artists whose practices routinely consider the culture of display, which has so readily embraced the figure of the curator as a mediator or conduit.

ELIZABETH SMITH My curatorial career has ranged widely over architecture and visual art and across a broad time span of mid-twentieth century to present day, and I feel this has been an extraordinary privilege. While the exhibitions I've organized are seemingly quite disparate, there are common threads. I have always been most interested in the relationship between art and society; that interest was formed during my student days, when I focused on connections between visual art, literature, politics, history, etc., and it developed in projects I later undertook as a

curator of architecture shows, including "Blueprints for Modern Living: History and Legacy of the Case Study Houses" and "The Architecture of R. M. Schindler," as well as exhibitions on the work of artists ranging from Jenny Holzer, Cindy Sherman, and Catherine Opie to Kerry James Marshall, Roberto Matta, Lee Bontecou, and Donald Moffett.

Additionally, I might describe my "curatorial agenda" as an interest in bringing underrecognized artists or ideas to light and helping to reposition them in an art-historical trajectory and/or in current discourse.

JOSEPH DEL PESCO I'm not primarily interested in exhibition making. I operate from the position that the standardized exhibition is an exhausted format and that audiences are either oblivious to the narratives that curators propose or that they are overinfluenced by them and see groupings of artworks not as individual voices in proximity but as singing the same song. Some might call this a lack of confidence in the viewer (who might be reconsidered as an active participant-producer in the attention economy) or say that I've just seen too many mediocre exhibitions, both of which are true. Ultimately, I find it more productive to start from a position of not-exhibitions and only move in the opposite direction when necessary.

> **PIGEON FANCIER** *That seems to be a perspective that is gaining currency, especially among younger curators. I'd like to look at this more broadly by asking, how has your thinking about your work and the role of the curator changed since you first started in the field?*

JENS HOFFMANN It seems that many people who are looking for progress in curatorial work no longer see the exhibition as a viable form for the display of art. I disagree and feel now more than ever the need to make exhibitions. I think that exhibition making can potentially reach far beyond the sphere of art and that is something I am investigating quite actively at the moment.

ROBERT STORR I have become ever less enamored of the concept of the curator as the protagonist of exhibitions, though I will concede that in a handful of cases one can, for better or worse, speak of a curatorial auteur. At his best and its best, Harry Szeemann personified that approach; at his worst and its worst, he did as well. It is much like what one can say of Joseph Beuys, who Szeemann so much admired, acting as the shamanistic protagonist of his work. But only a fool would try to create a hubristic persona like Beuys's today, and only the most desperate of wannabes would attempt to play understudy to Szeemann. Naturally, there are quite a few of them around, and sadly some very talented curators who should know better have succumbed to the temptation for greater or lesser periods of time.

More generally, I look forward to a redefinition of the curatorial role that—paraphrasing Clement Greenberg's definition of modernism and with as much polemical perversity as I can muster—consists, as I see it, in the use of the characteristic methods of a discipline to criticize the discipline itself, not in order to subvert it but in order to entrench it more firmly in its area of competence. Curatorial practice's area of competence is, first and foremost, art. When curators lose sight of that fact, and of art itself—no matter how critical any particular body of work may be for one or another aesthetic tradition or even of the idea of art—they almost invariably end up doing art and the public a serious disservice. Too often they are amateurs in other fields who grant themselves full license to speculate and invent without having studied those fields in detail or even fully reconnoitering them, and they end up doing bad sociology, bad history, bad philosophy, bad psychology, and, above all, bad politics.

Wide-ranging, unprejudiced, repeated, protracted, and in-depth looking constitutes the bare essentials of the curator's craft. Before you can bring anything to another person's attention, you must be able to see it and think it and re-see it and rethink it yourself.

PABLO HELGUERA I have become more aware of the emerging role of curator as producer, aside from the more familiar roles of the curator as connoisseur or as instigator of public debate. The emergence of art that really develops in relation to context and the discussions between the curator and the artist are blurring the boundaries of the professions

as we currently know them and raising important questions around the ideal qualities that one should be looking for, or hoping to promote, in the curatorial practice of the future.

LISA MELANDRI My idea of the role of the curator has remained pretty stable over the past fifteen years. The curator should be able to bring artists to the fore for the first time; reveal recognized bodies of work in a new way; notice, assess, and present what is percolating in the art world and distill it through the work of a variety of practitioners; and offer audiences new perspectives and also a deep and meaningful backstory! All that said, what has changed is that I am now far more understanding of all the practical concerns of exhibition making—that your curatorial vision must be circumscribed by the limits of budgets, the desires of lenders, and the realistic expectation of artists.

> PIGEON FANCIER *Nato, what about you? I imagine that your thinking has changed.*

NATO THOMPSON It has changed in the extreme. The major move has been into the field of public art and with it came an entire paradigm shift. I remember distinctly recalling when I worked at MASS MoCA that the major impasse in terms of a general public appreciating exhibitions was that they couldn't figure out why these things were art. I realized the question was a dull one and that the only real problem of people appreciating art was the frame of art itself. You don't need to know something is art to appreciate it. That seems sort of obvious, but the truth in that has been made more evident the longer I work at Creative Time.

The artist Tania Bruguera said to me, "I don't want an art that points at a thing, I want an art that is the thing." The frame of art often prevents things from being the thing. The bracket of the museum or gallery often shifts the lens of a project away from its being toward a traditional mode of representation. It is a shift that I find often in the way of the artists' intent.

Working in the public sphere can allow projects to escape the bracket of art, and often they can simply exist as unexplained phenomena in

the world. The more unexplained an art project can be, the more it can hum in that special zone relegated to art. It is all rather paradoxical but tangibly real. Some folks out there think that I am against the autonomy of art (a sort of dumbing-down theory that tends to only circulate in annoying art circles), but in fact, I am all for rescuing art.

Okay. So that is transformation number one. The other profound shift is that I am quite convinced that what many people think of as art is pretty much a modernism that lost its relevance somewhere in the early seventies. The high end of modernism (the kind that Hal Foster wrote about in *The Return of the Real*) gradually lost its relevance. At this point, cultural production is the language of life. The skill sets of art (the tasks of representation and making) were long ago evacuated as necessary requirements of art, and the idea of art has also escaped its grasp. All that art has today is a surviving infrastructure that replicates itself in order to survive. Let's not think that this is a tragedy; the good news is that culture is the language of life. Art has finally won!

Taking a step back to appreciate the complexity of what this moment means for curating and for the organization of aesthetic shifts across numerous demographics means, in a sense, thinking through the complexity of meaning production today. It is exciting and, in fact, possible. The trick is making new platforms that can contend with this contemporary moment.

ANNE BARLOW My thoughts on the curator's role have shifted, or perhaps it would be more accurate to say "expanded" over time, partly because of the contexts in which I have worked: from dealing with a permanent museum collection and temporary exhibitions program to organizing new media and public programs and to developing programs, such as Museum as Hub, that went beyond straightforward definitions and structures of exhibition making. While exhibition making has been the constant since I first started in the field, these other experiences have made it impossible for me to see curating as being confined to one way of working. Just as artistic practice continues to evolve and change, I think it's important that the field of curating is seen as expansive, where one can be open to things outside one's immediate frame of reference and encounter the unexpected.

HELEN MOLESWORTH I think the rise of the art fairs has been extremely detrimental to the craft of exhibition making. We have grown increasingly accustomed to seeing art installed very, very badly, with very little attention paid to how the adjacency of art objects challenges, compounds, and contradicts our conventional sense of individual meanings. Alas, I fear this mode of presentation has infiltrated many museum exhibitions. The single biggest transformation of the role of the curator in my professional lifetime has been the demonstrable rise of the project-based model of working with artists. In this model, the curator—who once might have been identified primarily as an art historian—has become, to my way of thinking, a "producer"—an impresario more attuned to the pragmatics of mounting an event/exhibition/project than a person engaged in creating the discursive field that permits an artist's work to become legible (not merely visible) to a public.

ELIZABETH SMITH I have learned more and more to trust my instincts about what stirs or moves me as an indicator of what might also have a strong impact on others. Earlier in my career, I would not have had the same kind of confidence about balancing the intellectual and the intuitive.

> **PIGEON FANCIER** *I'd like to move now to the role of place and the geographies of the art world. Someone who teaches young curators recently said to me that in this age of globalism, everybody's local is virtually the same. So I ask you all, does the local still exist?*

CARLOS BASUALDO I believe that the interaction between what's here and what's not is extremely complex, and it cannot be reduced to a language that functions by establishing oppositions and/or neatly differentiates between presence and absence—that is what for me the term "local" implies. In other words: Ghosts are everywhere and we live by them. Artists work with what's there—with what's in front of them—and they can see and smell and feel, and I think that is a wonderful

model. I believe I can say that I work with what's there, too, and that affects profoundly the projects with which I am involved.

ASTRIA SUPARAK The local still exists, yes, but there's a different relationship to the global now. The local is what creates the life of a city, but it's the relationship to the global that makes it resonate.

For example, the artist Jon Rubin and I, in curating "Whatever It Takes: Steelers Fan Collections, Rituals, and Obsessions," were working with an intense and thoroughly proliferative aspect of local culture in Pittsburgh: the fan culture around the city's football team, the Steelers. In Pittsburgh, Steelers fandom is a unifying force that crosses demographic boundaries of class, race, gender, and sexuality, and exists in every pocket of the city from anarchists to doctors to artists. Newborn babies at hospitals are wrapped, not in pink and blue blankets, but in team-colored "Terrible Towels." "Casual Fridays" at workplaces are awash in black and gold. Local politicians win with lawn signs the color of the team, and city streets are nearly empty at game time. Although our premise was that Steelers culture is Pittsburgh's popular culture, and the fans are its primary producers (rather than passive consumers of a branded product), it has significance beyond the region. Largely due to the mass exodus of laid-off workers and their families during the fall of the steel industry in the seventies, which coincided with the rise of the team, there are more than two thousand self-proclaimed Steelers bars and fan clubs worldwide, existing in every American state and at least twenty-seven countries. Other than this international phenomenon of Steelers fandom, the obsessiveness—the way, for example, the fans construct their personal and social identities in relation to the team—is like any other fan culture (*Star Trek*, Harry Potter, *Buffy the Vampire Slayer*, etc.).

Another example is our current exhibition, the Pittsburgh Biennial. Historically it focused on artists living in the region, but this is the first year it has expanded to include anyone who has spent a significant amount of time in Pittsburgh. (It's also the first year that it's moved beyond the founding institution—the Pittsburgh Center for the Arts/ Pittsburgh Filmmakers—to include coorganizers: Carnegie Museum of Art, Miller Gallery at CMU, and the Andy Warhol Museum). Pittsburgh, like many cities, has a large population of transitory

residents, in this case largely due to the universities, which attract students and faculty, and the fact that it's a cheap place to live. There is constant movement into and out of the city, and many people live here part-time.

For my section of the biennial, I selected Pittsburgh-connected artists who work collaboratively, highlighting projects that demonstrate the strength of collective voices in influencing the future of neighborhoods, cities, and nations, and the importance of intimate conversations and compassionate listening. This collaborative approach echoes the long labor and union histories of the area, as well as the biennial's new partnership among local art organizations. Although most of these projects have sections that are closely tied to the city, these parameters could apply to many other regions.

SEAN DOCKRAY AND FIONA WHITTON Terms like "local" and "global" do sound a little outmoded, but the simple fact that even the most global systems (financial ones, for instance) have extremely specific material expressions in different places means that they are useful terms, even though they're deeply interconnected.

That said, our organization is not local—the Public School organizes classes in several places, and what this means is that local groups of people decide what classes to organize in their city, how to structure them, where to hold them, etc. The class proposals are what are "global." (The Public School works in this way: anyone can propose a class, anyone can sign up for and discuss the proposal, and then certain proposals are transformed into real, physical classes.) So a proposal might come out of San Juan, Puerto Rico, and a class based on that proposal might be held in Los Angeles and Berlin. There will be differences and similarities in the concerns, languages, motivations, discussions, and so on. We are especially interested in the ways that the Internet allows for both dispersion and aggregation, for both making things common and making things one's own.

PAUL SCHIMMEL I have had the opportunity to chart the evolution of Los Angeles from a major regional center for contemporary art to a major international hub. The fallout from globalism is that, while the local still exists, consumerism has become the great equalizer.

RUBA KATRIB In my recently acquired post as curator of Sculpture Center in Long Island City, New York, I find there to be different notions surrounding the concept of the local. Being in New York City means that we are in an international hub that hosts artists and other arts professionals from around the globe at any given moment. Also, being located in Long Island City means being in a neighborhood centered on production—many artists have studios there. I think this has been a part of Sculpture Center's position and institutional history.

JESSICA MORGAN In fact, I currently have no "local," insofar as Tate took the unusual decision to separate "British art" from everything else and, working as I do at Tate Modern (the location of "everything else"), we are necessarily encouraged to find "local" elsewhere. Currently my local could be Beirut, Istanbul, Bangalore, or Lahore, but probably, more realistically, it does not exist. I often wonder what this means, and while the experience is in some ways welcome and liberating (I have never felt affiliated with any kind of "Britishness"), the result is perhaps unmooring for a curator in a national museum.

ERIC FREDERICKSEN I live in Seattle and work frequently in Vancouver. Seattle proved in music and Vancouver proved in art, decisively, that the local can only exist to the extent it is international.

I use port metaphors in talking about cities and art to the point where I'm not sure they're metaphors. My main one is that a city needs a healthy balance of trade—imports and exports. You can't isolate yourself and expect to create a scene from that isolation. But you also can't just buy yourself a culture.

Western Bridge, where I work, mostly shows artists from elsewhere, but we always also show artists from Seattle; Portland, Oregon; and Vancouver. Exhibition is only part of what an organization or institution can offer local artists; I know our activities have been important to artists we haven't shown. It's most important to me that we've made a space where the local and the international meet, in more ways than just that of hanging them in proximity to one another.

DAN BYERS Yes, the local absolutely exists—I live in it most days here in Pittsburgh, as do you wherever you are. There are some incredible artists

in Pittsburgh who are making work that is at once different from that of other artists and very much speaking of larger ideas. But there are also many artists here (as there are in New York, Philly, and elsewhere) who see only the most immediate community, opportunities, and problems, and respond in kind. Issues of space, cost of living, current events, populations, access to grants, exhibitions, etc., still very much influence the way people make art, anywhere. Knowledge might be more decentralized and available, but the means, motivations, and material facts of making art in a place remain. So that covers artists . . .

In terms of audience and institutional culture, the Carnegie Museum of Art is similar to large, semiencyclopedic museums in other noncoastal cities. It's viewed as inspirational and civic-minded, on the one hand (Andy Warhol, Mel Bochner, and a ton of artists in between took art classes here as children). But on the other hand, it's also seen as elitist, disconnected, and embedded in the city's power structure (class remains a persistent presence in the city that, despite recent developments, can still feel like a factory town). But a few things make us unique. One is the hundred-plus-year-old commitment to contemporary art through the Carnegie International and that exhibition's place in the city's popular imagination and history. Another thing that makes the museum unique is that we share an enormous building with a library and natural-history museum (with more than thirty thousand butterfly specimens; an incredible collection of dinosaurs, taxidermy, and gems; and ethnographic halls).

JENIFER PAPARARO The notion of the local, even though it has somewhat dissipated into the global ethereal, seems real enough.

A performance by Tino Sehgal that has museum guards walking around galleries and museums uttering the phrase "This is so contemporary" rings true at the Contemporary Art Gallery. The gallery's name broadly defines it as a somewhat specified platform for the exhibition of a nonspecified contemporary art, which responds to a broader context—namely, an international network of artists and discourses. Counter to the Contemporary Art Gallery's generic name, which serves it well but doesn't situate it geographically or establish a mandate beyond the exhibition of contemporary art, the gallery is grounded in the local, tangibly situated in Vancouver and intertwined

with the city's particular history. Whether we focus more generally on the city's recent status as the second-most-expensive real-estate market in the world, just below Hong Kong, or focus on the influence of Photoconceptualism (the Vancouver School), these concrete local conditions hold sway with the way art is perceived, impacting the framework within which it is presented, even when it is confined to the uniformity of the white cube.

In working with Instant Coffee, it is important to become interwoven into the local scene. One way we do this is by offering a service in the form of an e-mail LISTSERV that promotes local art exhibitions and related events. In Vancouver, we have four thousand subscribers and promote between fifteen and thirty different activities per week. Another way we situate ourselves within the local is to hold events in venues we design, where we ask local artists to exhibit, perform, and consume. When we opened the Light Bar in Vancouver, we were aware that we came to this idea because we lived in a city where the rainfall seems endless and the negative effect caused by the lack of sunlight is a common topic and an accepted excuse for antisocial behavior. The use of light as a remedy for SAD (seasonal affective disorder) is common among individuals, but we wanted to try its effectiveness by applying it to social situations.

It was essential that our lay research be somewhat proletarian, so we devised a bar as an appropriate setting. We also conceived of the bar as a venue in reaction to restrictive and retrograde legislation regarding the sale of alcohol. It is nearly impossible to open a bar in Vancouver. Using funding we secured from the city itself to promote culture to a world audience during the 2010 Olympics, we opened a bar that was city sanctioned but not compliant with its laws and regulations. The context of the Light Bar can be shifted. We've opened versions in the Netherlands and in Norway. The concept of the "art bar" has a long and global history, but our Light Bar was born of the local.

GILBERT VICARIO I think this goes back to the way I see my subjectivity and movement through the world as distinct. In other words, it's an individual's subjectivity that helps to differentiate the notion or usefulness of the idea of the local versus the global. I think this is a great moment to begin to reassess the value of the local as it pertains

to artistic practice but also in relation to its perception alongside the exponential growth of the art world in the last twenty years.

ELIZABETH SMITH In our global age, the local is becoming more and more significant everywhere. At my organization (Art Gallery of Ontario in Toronto) there is a deep and growing engagement with local practices and ways of thinking about art; in Canadian art generally, a mandate exists for institutions to serve as a platform for positioning local work in a national and international context.

> PIGEON FANCIER *Continuing with this line of questioning, I want to ask, can art exist outside of the art world?*

RITA GONZALEZ Artists involved with the Asco group felt like renegades ("elites of the obscure"), yet they were canny and resigned about their own place in the art world. I think many artists and curators I respect are interested in being apart from and a part of institutions, power circuits, art history, and market considerations. That is to say, we maintain an understanding of our mutual imbrications and connections to a sphere that is alien or incomprehensible to many, while still retaining a shared sense of commitment and, in a sense, belief in this thing we call the art world.

PABLO HELGUERA If in referring to the "art world" one were using Arthur Danto's definition of it—as the universal language within which art is designated and identified—then the answer would be no. That is, the idea of art is nothing but a convention of language, and if the system that creates that convention were not there to name it, then it couldn't be named, and if it couldn't be named, it couldn't fully realize its identity. However, when we refer to the socioeconomic spheres of professionals, art can and does absolutely exist independently of it.

There is a perception that art either is linked to the larger contemporary debates of art or is not; and depending on that question, it might be judged amateur art, outsider art, or folk art. In reality, art is made all around the world in a wide variety of different ecosystems

that are more or less disconnected with the centralized, dominant world of museums, publications, biennials, and so on. When seen from the "center," these "peripheral spheres" (just to somehow name them) generally might seem to produce work that is largely derivative of the historical debates that came, at some point, from the center. However, this is not always the case: on occasion, works that exist outside of that official "art world" and, in fact, works by people who do not necessarily consider themselves artists become relevant to the center.

JOSEPH DEL PESCO I hold several, in some ways contradictory, ideas of what art is and how it's meant to function or live in the world. Antonio Gramsci's idea of retaining both pessimism toward the intellect and optimism toward the will might inspire the skepticism and criticism we need to retain toward the potential of art's received value, meaning, and experience, while we advocate, interpret, and play host to art's milieu and critical frameworks. Art requires us to think in multivalent and even in non sequiturs about its presentation and reception.

I think the most successful kinds of art that exist in the outside world are only thought of as art by the art world. I contributed to a book called *Byproduct*, edited by Marisa Jahn, that identifies artworks embedded in alien environments such as businesses or government. It's unclear whether these projects should be understood as barnacles or medicine, but in many cases art and artists are understood as a foreign (invasive) culture representing a disjointed or conflicting set of values. It's in the instances that they're grafted onto those environments or assimilated into them that they seem to function best, but it is also then that they begin to lose their identity as art.

NATO THOMPSON There are many art worlds and there are many definitions of art. It almost makes the use of the term "art" more misleading than helpful. We would clearly think it was a rhetorical question if we were to ask, "Can the skill sets of representation exist outside of the art world?" If we were to ask, "Can video exist outside the art world?," it would be the same. So what is it we want out of this word "art," since it is clearly not anything specific?

There are spaces in which different things pass as art. I tend to appreciate the *Cabinet* approach, which is more "arty" than about art.

They might address the question of electricity, but they wouldn't do it specifically and solely from the perspective of an artist. They would instead recruit the perspectives of numerous curious types, from scientists to poets to historians to photographers. It is coming more from a style of curiosity than one specifically of the discourse and infrastructure of art.

I tend to follow institutions, artists, project spaces, magazines, and blogs that I think have a sense of purpose, integrity, and vision. These are the spaces in which I think art is possible, and I watch it come to life on a daily basis. They are few and far between, though. Many just replicate the conservative values of the art market or the boring studio practice being churned out by bad MFA programs. I think that art comes out of a thrilling melancholic engagement with the world, and some places in the art world are able to demonstrate that.

PIGEON FANCIER *Okay, that said, is there such a thing anymore as an undiscovered artist?*

MAI ABU ELDAHAB Undiscovered by whom? As people working in the international contemporary circuit of art, we often fall into the trap of thinking that we constitute the art world. In fact, we represent a very small segment of the world of artistic production. The network in which we operate includes globalized art spaces, large-scale biennials, kunsthalles, renowned commercial galleries, and a selection of contemporary-art magazines and journals. So, yes, of course there are a lot of undiscovered, interesting artists outside this circuit who are active within a different discourse, language, and scope of activity.

NICHOLAS FRANK Absolutely, all the time. It depends on the frame of reference. We have information saturation and total networking, but isn't it funny that we're always finding artists we've missed? Overlooked? Misunderstood? I'm pleased to see that Leon Kossoff has some currency lately; I'd like to see some focus on Ibram Lassaw. A recent trip through French public collections exposed me to the work of François Morellet and Aurélie Nemours, who were totally

new to me. On a recent visit to the Philadelphia Museum of Art, I discovered the work of Sylvia Fein, a Wisconsin artist of the 1940s previously unknown to me. The work of her male peers is much better known. My greatest curatorial effect is bringing attention to work that has been missed, passed over in the careening steamroll of art history, overlooked, underappreciated, ignored, dissed even. Opportunities for revival are always there, latent, reminding us that hindsight corrects our present vision. I'm uncomfortable with the notion of "discovery" in the first place, maybe partly because I've been researching the history of Indian tribes in Wisconsin. It depends on where you place your focus, how you recognize the limits of your focus, of your ability to see. We are discovering new things all the time, most of which have been right under our noses.

There's a painter in Milwaukee, Greg Klassen; he's been painting here seriously for twenty years, and he hasn't been discovered yet. He's a very good painter, but he and his work don't fit into an existing and current dialogue, which as we know moves the focus around and delimits it, sometimes to the detriment of "discovery." He studied under Gerhard Richter in Düsseldorf in the early nineties, then came back to Milwaukee and continued his project, which is a kind of tendril of Richter's concerns. He has produced a great body of work. Does it apply anywhere else? I don't know.

DANIELA PÉREZ An "undiscovered artist" is a term that I rarely use. It does make me think, though, of jet-set curators who like to feel they "discover" artists because they make them part of relevant projects that the artists would have never imagined at such points in their careers.

SARAH ROBAYO SHERIDAN For better or for worse, there will always be undiscovered artists. Given the fickle nature of the art world, the discovered artist is likely to fade into the other category. This process of discovery is perilous for the artist, who will have to survive the flights of fancy of the market to remain "discovered." I tend to find displeasure in exhibitions that adhere strictly to biographical narrative, claiming to draw closer to the person of the artist while drawing curatorial prestige from this discovery. The more interesting exhibitions stir conversation

about our place and time, perception, understanding, and history. That is a process of discovery in which artists should be subjects, not objects.

PIGEON FANCIER *How can contemporary-art spaces outside of major artistic centers make meaningful contributions to the field at large?*

PETER ELEEY They have to revel in their advantages of time, economy, and distance. Make shows that can't be (or aren't being) done in the big cities—shows that are too big, small, loud, soft, speculative, untimely, or uncool. You must make your space the place where artists have their best experiences and then go tell their friends; they will come make or show their best work with you and hold you close to their hearts. Likewise, make your openings special events that bring people into town, so they will go back home and talk up your shows and programs to people who will never see them (and who also will never see your mistakes). People in the centers always want something new to discuss, and you can give it to them in the form of a rumor. Seek wide press coverage, and help your local critics spread the word. Make good books that are distributed well. In short, give yourself a voice that is bigger than people think you deserve, and then make sure you deserve it.

SARAH ROBAYO SHERIDAN Throw a dart at a world map and you will more likely than not land on a community in possession of an example of the proliferating species called "centers for contemporary art." Tourism bureaus everywhere are trained to boast of their cultural vitality, whether or not their civic budgets actually support the arts. Often, it's a lot of hollow rhetoric. What constitutes a "major artistic center" is, of course, a matter of perception. Toronto, where I work, is the center of the art market in Canada, but as an art dealer remarked to me recently at a fundraising auction, "there are a lot fewer zeros in the figures here than you'd see in London or New York." The center is always relative.

A space's influence is generally proportionate to the locale it operates within. Apart from how many E-flux announcements you buy to assert your global status, there is still one tried-and-true measure:

artists talk to each other and tell each other where to visit, who is really supporting artists, and where to live to be able to make your art and not die trying. Scale is a very interesting question—when you work in a smaller space, your reach may be limited, but it can also seem more intimate, more meaningful, and more proximate to audience, integrating the production and dissemination of art more fluidly.

ROBERT STORR Right now I am overseeing the program of an art-school gallery dedicated to bringing works of art that students and faculty believe their peers should see for themselves, the better to discuss them together. It is a kunsthalle run by and for the school. It has no director and no curator. I raise money, advise others on the technical aspects of organization and installation, and try to play honest broker when selecting the proposals that will actually become exhibitions. To set the pace, I curate some exhibitions. My teaching colleagues have done others, and the rule is that we all must enlist and work with students when we do them. Students do some themselves with minimal faculty input. The work exhibited must come from outside the academic community—we do not want a vanity gallery or a networking site.

The goal is to open doors and windows onto the wider world, so that what is in the mind's eye of one person can actually come before the eyes of their peers. It is also a chance for students to learn by doing what professional curators must do, not in order to turn them into curators but to better appreciate their part in the artist-curator dialogue when they start to show professionally. The results have been mixed but so far never dull. I am enjoying the process a great deal, and I think others do, too. What they do not realize, perhaps, is how different things would be if there were a director, an agenda, a need to compete, a board. So far as all of that goes, though, ignorance is bliss.

DANIEL FULLER It is certainly cliché, but being in Maine gives me certain permissions that would not be possible within a large-scale museum or in a large-scale city. To be honest, several recent programs were of questionable legality. This isolation and independence permits risk that could, and should, potentially manifest itself in a project or program that might be emulated in a more metropolitan setting. There certainly are also pitfalls, such as virtually nonexistent patronage and

occasional neuroses about being away from the artistic centers. Yet, in my case, there is a distinct personality in Portland; people are hungry for art. The year 2011 brought us fifty-three thousand visitors, which is not bad for a town of sixty-five thousand people. You can see immediate returns on your efforts, and you frequently know your constituents.

NAMITA GUPTA WIGGERS Contemporary spaces outside of the artistic centers contribute significantly to scholarship. Otherwise the myth would be perpetuated that art only happens in those cities in which the College Art Association chooses now to host conferences: New York, Los Angeles, and Chicago. Those cities are undeniably the places in which the high concentration of artists pushes innovation and discourse; the craft world, however, is far more dispersed and fragmented. In this case, "operating from the margins" is not necessarily an accurate characterization.

Budgets and access to major works are limited in the periphery; however, experimentation happens in smaller institutions across the country. There are opportunities to explore questions, work, artists, and exhibition strategies that institutions in the largest cities with significant budgets to maintain and tourist populations to serve cannot risk. The competitive climate in major cities creates the need for institutions to be the primary cultural destination—and pushes name recognition and blockbuster focus to the forefront. However, when you are a primary destination in the middle of a small city or town in the middle of the country, you can tell local stories and test the limits of what curatorial practice in a museum setting can become in the next decade.

ANNE BARLOW Exhibition and residency networks, publications, international public forums, and the online circuits of information are all channels through which contemporary-art spaces outside major artistic centers can impact the field at large. Recent publications, such as the New Museum's Art Spaces Directory of 2012, profile the programmatic strengths of many spaces outside the so-called centers, building on the awareness of organizations that are in some cases primarily visible online or through more localized networks. While often lacking the resources of a major center, such spaces may have a

deeper relationship with their audiences or be open to testing ideas that may be difficult to try elsewhere, so this can affect the larger field in a number of ways. In some cases, small, artist-run groups have created experimental programs that have been "coopted" by larger institutions as a way of refreshing their own programs, whereas other nonprofit and museum spaces have become inspirational leaders not just in their own locality but internationally.

> PIGEON FANCIER *Thanks, Anne. That leads to my next question for all of you: what have you learned most from working with artists? What can they learn from you?*

ANDREA GROVER Artists are natural innovators, recyclers, makers, growers, modifiers, and rabble-rousers. Whenever a new invention emerges, they are the first to misuse it, adapt it, and change it for their purposes. They are the ultimate product testers of life. What I offer to artists is unfaltering belief in voiding the warranty.

CHRISTOPHER EAMON From artists, I have learned to see, to perceive, and to understand the working process. I hope that artists can understand from me that the role of a curator need not be only about power—the power to select—but may also be much more than that, like that of a storyteller. A group exhibition can take separate entities and individually treat them with respect while, at the same time, presenting them together with other artists to tell a story. Perhaps it is a hypothesis— such as this or that trend appears to be happening—or a story of how artists may or may not relate without subsuming each part entirely to the whole.

> PIGEON FANCIER *Can you give me an example of a decision you've made for which the goals and priorities of your institution had to take precedence over those of an artist or group of artists?*

RALPH RUGOFF While organizing "Psycho Buildings: Artists Take On Architecture" at the Hayward in 2008, I had a meeting with Gelitin to discuss their contribution to the show. Afterward, they came back to me with a proposal for a work that would involve a mass feeding of pigeons from one of the Hayward's sculpture terraces, at a set time each afternoon. From their research, they had determined that by the end of the show's run, as many as a hundred thousand pigeons would show up each day for feeding time. I had to wonder whether they had mixed up their Hitchcock references (thinking of *The Birds* as opposed to *Psycho*), but it was a brilliant idea that would have created a very uncanny atmosphere around the gallery each afternoon as thousands of pigeons began circling the building, awaiting their scheduled dinner. I was unhappy, though, with the idea of the Hayward maintenance team having to clean up the pigeon shit left by thousands and thousands of birds each day. While shitting on the museum might have had its ideological points in an artwork, it didn't seem fair to the people who would have to clean it up. So I asked them whether they would consider another idea—and they came up with the brilliant plan of flooding one of the sculpture terraces with ninety tons of water, turning it into a boating pond . . . which they did.

GLENN ADAMSON I'd say that any exhibition is, to some extent, a balancing act between the personality of the institution and that of an artist. In the case of "Postmodernism: Style and Subversion, 1970–1990," we had many cases in which artists needed to be talked into the very idea of participating—as postmodernism is such a toxic bit of terminology— which required further diplomacy to situate the works in question within a narrative. Most found it interesting in the end, but they weren't necessarily converted into self-described postmodernists. That's quite a specific instance, but in general my experience has been that artists regard group shows as Procrustean beds, which will inevitably simplify (or even falsify) their intentions. A few I've worked with actually like the transformative process involved in juxtaposition, which is great for the curator. But for the most part, artists are interested in their own ideas, not in curating. So it's a matter of damage limitation. You might say, why make group shows, surveys, etc., at all? Without them, you'd lose a rich and complicated register of exhibition making and ironically

miss out on one of the potentials of all artworks, which is to combine into dynamic configurations.

JENNIFER GROSS On one occasion, we were working with an artist-in-residence who was really disrespectful of the staff at the museum I was working at, and so, while we completed our original commitment to that person, we did not follow through with an additional project. Sometimes self-centeredness can be accommodated in an exhibition context, and it should be when it relates to artistic vision, but when an artist has signed up to work in a social context, especially if there are students or nonart affiliates involved, there has to be a common vision or the project will not be good for anyone, including the artist.

PIGEON FANCIER *Elizabeth, can you speak more specifically to the decisions made?*

ELIZABETH SMITH Recently, I invited artist Yael Bartana, an Israeli who represented Poland at the 2011 Venice Biennale, to bring her Venice project—the film trilogy titled . . . *And Europe Will be Stunned*—to Toronto and to present it as an exhibition at AGO. I had to make several decisions involving allocation of resources owing to institutional considerations that departed from those of the artist. These included how to advertise and talk about the project because of its potentially sensitive subject matter, how to program around the exhibition, and whether to contribute funds to a publication being developed by a consortium of European institutions also planning to present the trilogy later in the year. The decision not to contribute to the catalogue was undertaken purely for financial reasons, as our costs had gone up significantly in other areas of the presentation, while the other two decisions were made following extensive internal discussions and consultations with colleagues in the field to determine an approach and a course of action that would best serve the institution's need to avoid potential controversy that would detract from the intention of the artist and integrity of the work.

HELEN MOLESWORTH I don't think I have ever placed the needs of the museum above those of the artist. However, I have managed to avoid this problem only by carefully deciding which projects are best for the institution I work in. If we believe that context creates meaning, and that art is not autonomous, then it follows that not every project is right for every institution. This is one of the reasons I have found it interesting to work in a variety of types and scales of institutions.

> **PIGEON FANCIER** *Many contemporary-art curators see their role as one that gives visibility to and makes sense of the work of exemplary artists. I have to ask you—and I'm being deliberately vague here—should we celebrate the achievements of great artists who are bad people?*

LANCE FUNG Never. If the question is whether we should celebrate the achievements of an artist with bad character traits—arrogance, greed, and insecurity, for example—the answer may be debatable. Everyone has personality flaws, and artists seem to be more prone than most people to many of them. But for me, art has moral and social power and should come out of and speak to what's best in us. I believe that great art is about building communities and connecting with other human beings. I don't think that truly great art, the kind of art that we should celebrate and support, can be made by "bad" people. If art that's in opposition to those values—art that denigrates others or belittles people, or art that is cynical and exploitative—is celebrated as "great," I think that we should have the courage not to support that negative behavior.

PETER ELEEY Of course. A stroll around the Met makes clear that we don't even know the names of the people who made many of the great objects that populate the history of art—among them perhaps murderers, rapists, and thieves. Essential to great art is the notion that it belongs to something bigger than its maker, its time, its current owner, and its viewer. (How else, we might point out, could the relocation of the Barnes Foundation be justified?)

PABLO HELGUERA The question appears to be a verbal sleight of hand. To the question of whether ethical standards should inform our aesthetic values, I believe the answer has to be an emphatic no—mainly because using moral judgments to evaluate artwork is a poor and dangerous practice. Who determines who is a bad person? By the standards of a very conservative and intolerant public, practically every contemporary artist is a bad person.

When artist Cildo Meireles set a number of chickens on fire as part of his work *Tiradentes* in 1970, he was making a commentary on the military dictatorship of Brazil. I consider the work to be one of the most important conceptual and political gestures by any Latin American artist, while I am also aware that certainly the work would be condemned by PETA and many others. Maybe Meireles is a cruel person for having sacrificed these chickens, but to condemn his work under that moral standard not only brings us to a parochial aesthetic but also makes us ignore the larger historical context under which this piece was produced.

MAI ABU ELDAHAB This is a really strange question: I'll assume that "we" refers to art professionals, and "bad" refers to ethically problematic stances or actions beyond the scope of personal lives and the art world. Making art is more often than not a humanist and positive endeavor that involves trying to share an idea and an aesthetic that contributes to the betterment of human life—I am definitely not suggesting that it is altruistic but that it is an attempt to productively critique the human condition. I find that this desire, although it might be acted out narcissistically and egotistically, is rarely coupled with seriously criminal or evil acts.

ERIC FREDERICKSEN I decided years ago that I'd rather work with artists I liked. I figured there were plenty of other curators around who didn't mind working with the nasty ones.

But beyond simply wanting to enjoy myself, and contrary to the modernist myth, I do, somewhat embarrassedly, believe that the best art is now made by good folks.

PIGEON FANCIER *While we are talking about the relationships between artist and curator, I want to ask the younger curators assembled here whether they think that curators make artists or artists make curators?*

CLAIRE TANCONS I am not interested in perpetuating the increasingly artificial distinction between curators and artists. I do not know who needs who, and more than likely, we only need each other to the extent that we're mutually empowering each other to create agency for our constitutive audience.

The skills, knowledge, experience, and expertise—or lack thereof—influence the curatorial and artistic elements that are needed to realize a project. I'd like to think of this as a field of agency—and would prefer not to characterize the roles of curators and artists.

PIGEON FANCIER *Then has the curatorial field evolved to a point where artists have become redundant?*

ASTRIA SUPARAK I, too, don't like to distinguish between artists and nonartists. I'm constantly learning from the people who I work with, and I approach every exhibition as a collaborative enterprise. I guess the main thing would be the impetus to question established ways of working, belief systems, traditional forms, and so on. We live in a very conservative world. Artists look for new ways to express ideas and to subvert the status quo, and I find inspiration in that.

MARK BEASLEY Curators need artists for the simple fact that artists make things and are engaged in risk to a great extent. There are demands made on curators that require some sort of line to be toed. With notable exceptions—usually led by artists as briefly touched on above—the curatorial field is one of middle management. That said, perhaps the term or title "artist" is used too readily; as John Waters recently pointed out, "When people say to me, 'I'm an artist,' I think, 'Yeah, I'll be the

judge of that. Let's see your work.'" Perhaps it could be like a license that can be revoked or that comes with a three-year guarantee.

If the suggestion were that the role of the curator is limited to just tinkering with history—things previously made by artists—then clearly no, the role and point of the artist speaks for itself. At some point in time, a curator might more readily play with curatorial ideas, regarding the many conferences, symposia, and publications on the subject that inadvertently established the rule book. To that extent, culture requires the artist to lead the curator on a merry dance down muddy paths.

PIGEON FANCIER *What ethical considerations, if any, have most significantly impacted your curatorial thinking?*

JENNIFER GROSS Maintaining respect for the living artist's opinion regarding the presentation of their work after it has gone into the public realm and defending the integrity of that work.

MARK BEASLEY Is boredom a matter of ethics? I would hope not to bore.

JENIFER PAPARARO Over the last few years, I have been intrigued by the work of the British documentarian Adam Curtis. One of the key currents crossing Curtis's films is that he tracks the problematic development of the notion of the individual. He draws lines that show its advance through the creation of public relations by Edward Bernays, the application of game theory, the mathematic equations of John Nash, and the economic think tanks inspired by Ayn Rand. What Curtis manages to draw out are justifications for privileging the individual, the ethical position being that if you were to do what is right for you then everyone else would benefit. Altruism should be denied. The weight of Curtis's detailed, albeit erratic, history seems an absurdist tale, but we know from the trickle-down economics of 1980s conservative America that it has real consequence.

Ethically, I want to work in opposition to these belief systems, in a manner that complicates the notion of subjectivity instead of reifying the singularity of the subject. If I were speaking only in the voice of

Instant Coffee, I would start with a series of aberrant aphorisms: "Get social or get lost"; "it doesn't have to be good to be meaningful"; "we are no better than you." As a collective, we take these as loose guidelines for making art, gathering audiences, and justifying our existence, as well as providing some levity. Curatorially I see them as terms of engagement, not only within the core of my practice but also in relation to audiences (imagined and real), the artists I work with, and the art exhibited. The key is to privilege the relations between these elements over their component parts. This is not to say that each doesn't retain special and focused value; they are central factors but always and only merely pieces, and as pieces they have to be perceived within a larger whole.

ROBERT STORR To be effective as a curator—which means to do right by the art you want to bring to the public's attention, right by the public that comes to see what you have to offer them, and right by the artist who made the work (in that order)—you must be ingenious and at times guileful, but when push comes to shove you must also be straightforward and accountable in all essential dealings, and you must respect professional standards and stand up for them when challenged or subverted.

- You must listen to everyone legitimately involved in a project on all pertinent subjects before you start to make decisions.
- Since you as curator are ultimately responsible for how things turn out, you should have final say and you must exercise it. This means making or signing off on and assuming full responsibility for all decisions regarding selection of works, design of spaces, content and design of the catalogue, tone and design of educational materials, participation and focus of educational programs, and tone and design of publicity.
- The interpretation of the work you present may be profoundly affected by any and all of these things, and you as the presiding "editor" of the whole enterprise must know enough about how they do, whose advice to trust, and the consequences of different strategies to make wise choices and bring people around to them.
- It means personally negotiating all major issues with the artist or artists, estates, or galleries in question rather than delegating

the difficult parts of the process to others or surrendering the authority to do so to others who do not bear the full burden of the show's success or failure, as the curator does.

- Never yield to dealer pressure. Walk away from projects or acquisitions if necessary.
- Never yield to trustee pressure. Walk away from jobs if necessary.
- The same holds true of administrative pressures; if a director thinks they could make exhibitions better than the curator in place and habitually overrides him or her, then the curator should hand the director the keys to the car and take a hike.
- Never yield to lender pressure or donor pressure. If they want to run a museum or create a shrine to themselves, they should create their own rather than attempt the leveraged takeover of an existing public institution.
- Never yield to sponsor pressure once an agreement for support has been reached and the limits of a sponsor's prerogatives have been set. Never get involved with a sponsor who asks for too much up front.
- Once you have come to an understanding of how you will work together with an artist, it also means never yielding to the pressure an artist may try to exert in areas not covered by that understanding.
- Curators should not be the center of attention in the exhibitions they make, but they should be the pivotal professional arbiters of how exhibitions are made.
- When the going gets rough and the choices are all bad, just remember what Robert Townsend says at the end of *Hollywood Shuffle*: "There's always work at the post office."

HELEN MOLESWORTH I feel like ethical considerations drive almost everything I do: Have I opened myself up enough to the concerns of the artist? Have I created the conditions of trust and affection that permit the dual role of critique and caretaking that are so central to the curatorial endeavor? Have I imagined the experience of the public? Have I anticipated their questions? Have I provided enough information for the public to have the richest possible experience of what is on view? Have I adequately thanked and compensated all of

the people who have worked to bring a project to fruition? Have I helped to create an environment where people feel like their daily labor has meaning and value? Have I successfully created a space where the experience of love and curiosity can flourish?

JESSICA MORGAN Aside from an acute awareness of a gender, class, and racial imbalance throughout institutional activity, I probably have fewer considerations than I would like to admit. Perhaps at heart is a basic desire for accessibility. That Tate (like all UK national museums) is free of an entry charge is a considerable part of this but not nearly enough.

JOSEPH DEL PESCO I take it as an ethical imperative not to think or act in an authoritarian way. To this end, I approach artworks and critical ideas dialectically and contextually. That said, everything in moderation can also be a kind of extreme. It's important to act and think against one's tastes or inclinations often and repeatedly. A fairly even distribution of power helps. I work horizontally and collaboratively as much as possible.

> PIGEON FANCIER *The curator Chus Martínez, who sadly couldn't join us today, recently asked her colleagues on a panel at the Guggenheim Museum whether art is a "liberation of the social" or a "liberation from the social." What do you think?*

ANDREA GROVER Both. Being an artist allows you to live and act outside the confines of normal societal protocol; whether that is a liberation of or from the social depends on how many people join you.

> PIGEON FANCIER *How can curators help improve conditions in society for the less fortunate?*

MAI ABU ELDAHAB This question means a lot of different things in different places. As I've been primarily working in a Western European context, the patronage I have mostly dealt with is that of the state. In some ways, this is a privileged situation that ideally creates room for autonomy. However, it also leads to situations in which art institutions are easily susceptible to being instruments of state cultural policies. Although a relationship of reciprocity is possible in articulating what this policy should be from the ground up, this is sadly often not the case as corporate models are increasingly imposed on cultural production, and a huge and unproductive language gap widens between the different actors involved.

RALPH RUGOFF It's tempting to say that if you really wanted to improve conditions in society for the "less fortunate," you would only curate exhibitions that offered members of this huge group a platform for making public their needs and voices. Some curators do take that approach more or less, and perhaps, at times, it has made a difference. Yet I'm not thrilled at the idea of a curatorial horizon limited to pursuing an agenda of social justice. I don't think substantial social change is going to be galvanized by actions in museums and galleries. But I would say that curators can help, in their particular area, by making sure that their exhibitions address in some way and are available to people who are socially excluded or economically marginalized. This can happen with the help of "education" or "learning and participation" programs that serve as user-friendly interfaces with the exhibition, but it also needs to grow out of the kind of material that curators are choosing to present.

Almost all really interesting art can engage and reward most people who spend time with it, but if you weren't familiar with the languages being used, it might seem perplexing. (Just as looking at the engine of a car is perplexing when you've never read a book on auto mechanics.) So it's a small thing, perhaps, that curators can contribute. (Of course, there are many things you can do on an everyday level as well, including mentoring young curators from different backgrounds and speaking about what you do to a variety of audiences—and then as a private citizen, your opportunities to help improve conditions are endless.)

PIGEON FANCIER *Like it or not, most of us need to rely on the charity of others to do the type of work we do. What is your relationship to patronage?*

ARAM MOSHAYEDI It's possible that we all, in having given up on the idea of independence, have given up to the routine of codependency. This is the condition of our age, and a shortage of adequate funds creates an atmosphere of competition within the field. In most cases, this manifests itself as a curatorial neurosis and an overall preoccupation with money rather than a commitment to ideas. I've found this to be particularly evident working almost exclusively within the context of nonprofit organizations. The influence and power of the art market has made it increasingly difficult for curators and writers to avoid being instrumentalized and tethered by what Clement Greenberg poignantly referred to as "an umbilical cord of gold."

JENS HOFFMANN At California College of the Arts and the Wattis Institute, we are highly dependent on the support of patrons, and I am thankful to all the people who have helped and supported the exhibitions I have been involved with and who have given to the school to support fellowships. I am very open and frank about my political convictions and never had any difficulties addressing my positions. This might mean that my ideas are not as radical as I think they are or that most art patrons are actually very open to various political beliefs.

SEAN DOCKRAY AND FIONA WHITTON We haven't been tested too many times on whether our relationship to patronage aligns with our political commitments, but we have turned away from money on several occasions when we felt as though the financial support would change our programming or when we would have to look in the mirror knowing that our little institution was funded by an entity that we found deeply troubling. These are very common reasons for turning away from patronage, when the "strings attached" or the "selling out" becomes too much to accept. There are some lines that we are not willing to cross, even if that means our organization would collapse—it's not that important, and the energy will become something else.

But for now, we're realists finding support for the organization where we can.

PAUL SCHIMMEL Having worked in Houston at the Contemporary Arts Museum, in Orange County at the Orange County Museum of Art, and in Los Angeles at the Museum of Contemporary Art, I have learned that party affiliations have little impact on the patronage of contemporary art. It comes down to the individual, rather than to the individual's political orientation.

ANNE BARLOW My relationship to patronage changed dramatically in 1999 when I moved from a system that was primarily funded by local government to one that relies on a combination of sources, including foundation, corporate, government, individual, and board support. There are, of course, pros and cons to each of these systems—and the contrast between practices in the US and Europe is now less stark owing to shifts in the economy and funding structures—but the way in which patronage works here is fundamentally different.

Overall, I try to keep my relationship to patronage a meaningful one by avoiding funding that would affect the integrity of an institution or program and by working whenever possible with individuals and in contexts that are supportive and encouraging to contemporary artistic practice. At Art in General, this approach recently led to the creation of the Commissioners Circle, a group of patrons who passionately believe in the process of commissioning and supporting artists whose work may not otherwise be realized.

PIGEON FANCIER *Why should government fund the arts?*

ASTRIA SUPARAK Art encourages creative thinking, alternative points of view, and risk taking—values that aren't always profitable or popular in a capitalist society. Artists are almost always underpaid, yet the contribution that they make to our neighborhoods, cities, and countries is invaluable. The arts enrich every aspect of our daily life.

NICHOLAS FRANK A great question. I've been poring over old issues of *M/E/A/N/I/N/G* magazine, which arose (publicly funded) right around the time of the demise of the National Endowment for the Arts' individual-artist granting system. It reminded me of the difference an annual $170-odd million could do for art and artists in this country.

The first thing is to recognize that even the most detached forms of contemporary art are absolutely essential to society. My bottom line is that anyone in this profession who thinks otherwise, or doubts this even for a moment, should consider a different line of work. I don't like to lean on statistics, especially for economic justification, but the fact that in a year more people visit the Metropolitan Museum than Yankee Stadium makes an elegant point. The effect of art is hard to gauge, however, and gets grossly oversimplified. The whole point of the thing, for me, is to keep complexity alive and breathing, resolutely and defiantly, within the popular discourse. Our government is actually designed to promote dissensus, the sustenance of the minority. I feel I must remind my fellow citizens that the essence of democracy is to protect the minority from the tyranny of the majority, and arguments toward popular opinion tend to speciously overlook this essential fact.

PABLO HELGUERA I would first argue that museums are seldom a local or national priority—instead, they are usually placed in the last echelon of priorities at any given time, let alone at a time of crisis. Part of the problem is that museums are perceived as static institutions that only contain objects, like large warehouses, while their educational role is underestimated. Museums are a unique vehicle for informal learning and for constructing a collective sense of self—not only of the shared past but of the present. If a government believes in educating their citizens and maintaining a sense of collective purpose for their communities, museums should be central in their thinking.

PIGEON FANCIER *Is there anything that curators can do to counter the perception of art as a luxury asset?*

GLENN ADAMSON Should we be countering that perception? I would regard it as absolutely accurate. Art is now—and almost always has been—produced at the margins of the economy, for the pleasure and gratification of its patrons. I don't mean that to be cynical, it's just a fact; and to pretend otherwise would be dishonest. The question is, what can art do as well as being a luxury asset—what does the culture at large gain from the activity.

Here Walter Benjamin's famous observations about the effects of reproduction continue to be worth considering—and increasingly more persuasive than Theodor Adorno's insistence on detachment from mass culture. Artists who achieve a measure of celebrity attract a lot of negative attention—I am thinking of Tracey Emin, Damien Hirst, and Matthew Barney—but in the nineties they did a lot to enlarge the content of the public sphere, while still making luxury commodities. In our own fragmented, web-based world, in which museums and galleries have ever-increasing currency, that factor of celebrity may be less important. I think it's easier and easier for a work of art to function democratically (through replication or display) while still being owned by some fat-cat investor whose politics you might well find revolting. This ability to traverse multiple ideological registers is one thing that makes art unusual—most commodities don't work in this way because they carry their ideological "brand" with them. The democratic effect of art may itself be marginal, but it's a margin worth exploring.

DANIEL FULLER It's possible that the majority of art is indeed a luxury asset of the one percent. That said, there are no "market considerations" in Maine. I attempt to do my small part in changing that perception by remaining open—open to artists and open to ideas.

Just in the past week, we hosted numerous temporal events, including a monthly series of seventies surf films with Maine's small but avid surf community; served as a practice facility for the ICA/ Maine College of Art Free Radicals Futbol Club; presented a lecture by Charles Simonds; hosted a weekly reading group; and provided a venue for a concert by Black Lodge, an MECA student noise band. Needless to say, I am continuously lacking for sleep.

This week has been particularly busy—it's been a perfect storm of events—but we truly do try to remain open as a public square or

at least as an odd intersection where subcultures exchange ideas. The surfers may not come back through the doors until the next screening, but you never know whether a flyer for another event might catch their eyes. The goal is to cross-pollinate audiences and communities, to frequently offer interesting programming alongside interesting art.

This coming week, for one night only, I am extremely excited that the ICA's storefront space will be transformed in PAMFILO, Maine's only traditional Filipino pop-up restaurant. This began as a student's class project and developed into a fully functional community happening, complete with family recipes, dance (Centre of Movement School of Performing Arts), and music by the Ramos Family Band and DJ ASIA.

VALERIE CASSEL OLIVER There are a lot of pressing issues; however, what is, and what has remained, important to me is rooted in a dialogue that began in the 1980s, which called into question how people are represented or, more importantly, not represented in the history of art. There is much work yet to do with regard to building repositories of information and integrating key figures into the canonical histories that form our understanding of modern and contemporary-art practice. While I do not want to be perceived as undertaking a "revisionist" point of view, I also do not want to buy into the concept that we are beyond the need to insert this history and these narratives into the canon. It really is about building a more complete understanding of the history of art for future generations.

LANCE FUNG The fallacy that the art world comprises the one percent is a joke. I do not know too many art students, young artists, gallery workers, art shippers and installers, auction employees, critics, museum employees, or curators who are in the one percent. These one-percent folks play a necessary role in supporting the art world in commercial and philanthropic endeavors, but they are not the only participants in the art world.

PIGEON FANCIER *In closing, I want to thank you all again for your extraordinary generosity today. I have found*

what you have had to say very interesting, and it has left me with a lot to think about. I have just one last question: what pressing issues in the field of contemporary art are not being dealt with in curatorial practice at the moment?

MARK BEASLEY Economic class, the anxiety of influence, and why stand-up comedy has the edge?

GLENN ADAMSON Curatorial practice is so vast and varied that it would be difficult to say that anything is being completely ignored. But as a craft specialist, I am always struck by contemporary art's dysfunctional relationship with its own forms of production. My guess is that historians in fifty years will look back at our moment and prioritize the systems of making prevalent in the art world, not the content or imagery or ideas. That's partly because the art itself is so promiscuous as to discourage any form of generalization. But it's also because "production values" have become increasingly crucial, and the means of achieving them—often through specialist fabrication firms—ever more important. There isn't an honest conversation about this at the moment. The fabrication firms tend to keep a very low profile, as if they were research labs for corporations under nondisclosure agreements. We need to have a better understanding of this rapidly proliferating phenomenon, its benefits and drawbacks.

HELEN MOLESWORTH I'm not sure how to answer this question, as it implies there is a disconnect between practice and exhibition, which I don't quite believe. I do think that neither artists nor the institutions of art have grappled with the explosion of the sheer quantity of artists and artworks in the culture. In practical terms, the growth is unsustainable: museums are not equipped to be the caretakers of the amount of "stuff" currently being produced. What will happen to it all?

CESAR GARCIA For me, it is the impact of the economic downturn on museums and institutions and their ability to support and commission new work. We are seeing museum endowments shrink and, more broadly, support for the arts and humanities diminish, so as curators,

I think, we are being challenged to reimagine how we can continue to support challenging work and the practices of artists without having to retreat to the safety of rotating presentations of permanent collections. With an abundance of international biennials, pressing concerns about the sustainability of localized cultural landscapes have also come into focus.

In terms of exhibition structures and formats, the role of dance, theater, performance, and other body-based practices within museum exhibitions is also something we need to have a more rigorous dialogue about. We have seen a few recent examples of approaches to the presentation of retrospective exhibitions of artists who work mostly in performance, but I think this type of focus needs to be translated into group-show and large-scale exhibition contexts. Rather than organizing performances as separate or "otherly" events, we need to consider how these practices can be better integrated into the conversations generated by more conventional gallery presentations.

CLAIRE TANCONS That the vast majority of the world's potential art audience is not going to attend museums, galleries, biennials, and art fairs, no matter how much they expand and multiply around the world. These institutions are more interested in expanding their financial and real-estate holdings than they are in reaching out to underserved populations no matter what their "community outreach" rhetoric might be. One only need observe the locations to which these institutions are moving—follow the money—to know that it's not about audience but assets development. The same applies to universities. The conflation of financial and artistic interests is being discussed in highbrow forums but is not really addressed in ways that would transform the hegemonic structure of interests and institutions around contemporary art—beyond small individual initiatives or small collective initiatives, including those around the Occupy movement in New York.

CHRISTOPHER EAMON The dovetailing issues of the private museum and large-scale entertainment. There was a period when it was seen to be within the purview of the curator in the institution to educate both the public and the patrons. The fashion-entertainment-art complex is not adequately discussed in contemporary art. It might seem to be

too dangerous to discuss this, but it is necessary. It affects everyone when we only count the bottom line. Then art that is relevant, smart, complicated, difficult to understand, quiet, understated, and even irreconcilably eclectic gets lost. The resources, the spaces, and the labor go elsewhere, to empty spectacle. It may resound, famously, as a simple image in the mind's eye, in print, or in the media sphere, but as if it is describable only in sound bites, it can go no further. This, for me, is the most pressing issue of the current moment.

LANCE FUNG I suppose it is the simple fact that the visual art world isn't the center of the universe. In another era, the visual arts were a barometer of what was important, serious, and topical. Artists seemed to be connected to the most crucial social and philosophical issues of the day and deeply committed to addressing them. The rest of the art world exhibited their work, fueled their debates, and sometimes exploited their talents. The influence of the visual arts was pervasive, and other cultural fields—fashion, architecture, design, advertising, pop music, and so on—followed its lead.

This new era that we are in—whether it's attributable to commerce, egos, or the Internet—is one in which the art world seems to be chasing its own tail to find the newest and greatest style or artist. I so often feel that the cutting-edge ideas are coming from arenas that used to look to the art world for guidance and inspiration. Those fields are now providing fresh points of view and new approaches to aesthetics.

Perhaps if the art world were to settle down and refocus on a sincere and passionate exploration of what great art can be, a rebirth might occur in which the visual arts would again be less about what is fashionable. The art world cannot aspire to setting the tone again or connecting to the central concerns of the human condition unless a new groundedness returns. Throughout art history, various art movements have reacted to each other and then pioneered new forms of thought. This cannot be done in an artificial manner, as is the case at present.

INGRID SCHAFFNER What strikes me as pressing in the field of curatorial practice is the issue of craft. It's a cliché by now: anyone who opens a boutique, makes a sandwich, posts on Tumblr, or accessorizes can now call herself a curator. So how do we as curators claim the authority

of our own profession? What makes putting together an exhibition fundamentally different from, say, shopping or engaging in other passive forms of consumption?

An exhibition is, like art itself, a form of engagement. And it takes knowledge, skills, and expertise—bookish, arcane, experiential—to absorb a viewer in the act of looking enough to animate the ideas, forms, issues, or just the thing itself in their own minds. Let's call these skills "the craft." And here let me conjure Karen Kilimnik's painting by that very title: a purple nocturne of an empty stage set, illuminated by three tiny candles.

ANDREA GROVER I'd like to see more high-caliber curatorial projects embedded in the real world, outside of rarified institutions, and without dependency on art-world currency. While there are many art and performance festivals that take the phenomenological "lived experience" approach, serious exhibitions still remain in the closed quarters of art institutions (for reasons that are obvious—security, conservation, and so on).

PIGEON FANCIER *Hanru?*

HOU HANRU Curating as a living process, a performative experience inspired by but distinguished from both real life and intellectual reflections. The exhibition as site of production of new social projects, contemporary art and globalization, migration, urban transformation, public space, politics and alternative ways of existing and creating, social construction . . . Experimenting as permanent state of being. Resisting all kinds of established powers and orders. Self-organization, urban guerrilla, and direct democracy . . . and the invention of new "institutions" as networks of global insurrection against the dominant culture of fear consciously or unconsciously promoted by the current bureaucratic and corporative spectacles and their institutions.

BIOGRAPHIES

Glenn Adamson is head of research at the Victoria and Albert Museum, London, and a specialist on the history and theory of craft and design. He is coeditor of the triennial *Journal of Modern Craft*, the author of *Thinking Through Craft*, *The Craft Reader*, and *The Invention of Craft*. Adamson's other publications include the coedited volumes *Global Design History* and *Surface Tensions*. His most recent project is a major exhibition, and accompanying publication, for the Victoria and Albert titled "Postmodernism: Style and Subversion, 1970–1990."

Anne Barlow is director of Art in General, New York, which supports artists primarily through the commissioning of new work and international exchange programs. From 1999 to 2006, she was curator of education and media programs at the New Museum, where she oversaw its educational and public programs, initiated and developed Museum as Hub, and organized numerous exhibitions and performances. Prior to moving to New York in 1999, she was curator of contemporary art and design at Glasgow Museums, Scotland.

Barlow is curator of the 5th Bucharest Biennale, "Tactics for the Here and Now" (2012).

Carlos Basualdo is Keith L. and Katherine Sachs Curator of Contemporary Art at the Philadelphia Museum of Art and curator at large at MAXXI Museo nazionale delle arti del XXI secolo in Rome. His recent exhibitions include "Dancing Around the Bride: Cage, Cunningham, Johns, Rauschenberg, and Duchamp" and "Michelangelo Pistoletto: From One to Many, 1956–1974." He was the lead organizer of "Bruce Nauman: Topological Gardens," which represented the United States at the 2007 Venice Biennale, where it was awarded the Golden Lion for Best National Participation. He was also a part of the curatorial teams for Documenta 11 and the 50th Venice Biennale, and he conceived and curated "Tropicália: A Revolution in Brazilian Culture," which traveled internationally.

Mark Beasley is a curator and writer based in New York. His recent curatorial projects with Performa include Frances Stark and Mark Leckey's *Put a Song in Your Thing*

at Abrons Arts Center, New York; Robert Ashley's *That Morning Thing* at the Kitchen, New York; Mike Kelley's *Day Is Done* at Judson Church, New York; Arto Lindsay's *Somewhere I Read*; and "A Fantastic World Superimposed on Reality," an experimental music festival, cocurated with Mike Kelley. As a curator with Creative Time, he organized "Plot09: This World & Nearer Ones," "Hey Hey Glossolalia: Exhibiting the Voice," and Javier Téllez's critically acclaimed film *A Letter on the Blind*. In 2011, he established the Malcolm McLaren Award at Performa presented by Lou Reed to Ragnar Kjartansson. He is currently curator at large at Performa and is a PhD candidate in fine art at the University of Reading, UK. His first LP with the group Big Legs will be released in spring 2013 on the London- and Amsterdam-based label Junior Aspirin Records.

Shana Berger is an artist, writer, and curator who lives and works in York, Alabama. She is currently the codirector of the Coleman Center for the Arts, where she is working on an upcoming intervention with Alfredo Jaar.

Dan Byers is associate curator of contemporary art and associate curator of the 2013 Carnegie International at the Carnegie Museum of Art, Pittsburgh. In addition to projects involving the museum's permanent collection, recent exhibitions include solo shows by Cathy Wilkes, Ragnar Kjartnasson, and James Lee Byars.

Joseph del Pesco is the program director at the Kadist Foundation in San Francisco.

Sean Dockray and Fiona Whitton are the founding directors of Telic Arts Exchange, Los Angeles, a nonprofit arts organization providing a critical engagement with new media and culture; and the Public School.

Christopher Eamon is an independent curator and writer. He has curated exhibitions at international museums and galleries and published books on film and video art. He is the former director of the distinguished Pamela and Richard Kramlich Collection, San Francisco; and the New Art Trust; and former assistant curator at the Whitney Museum of American Art. His publications include *Anthony McCall: The Solid Light Films and Related Works* and writings on film and video art from 1950 to 1980 in *Film and Video Art*, and he is the

coeditor, with Stan Douglas, of *Art of Projection*, an anthology on the history and significance of projected images from the eighteenth century to the present.

Mai Abu ElDahab is a curator based in Brussels. From 2007 to 2012, she was director of Objectif Exhibitions in Antwerp. She has recently published several books, including *From Berkeley to Berkeley, After Berkeley, Hassan Khan: The Agreement*, and copublished *Circular Facts*, all available from Sternberg Press.

Peter Eleey is the curator of MoMA PS1. He was previously visual arts curator at the Walker Art Center and a curator and producer at Creative Time.

Nicholas Frank was curator at the Institute of Visual Arts (Inova) in Milwaukee from 2006 to 2011, and he currently teaches in the Integrated Studio Arts program at the Milwaukee Institute of Art & Design. His heavy-metal séance band, Demono, recently released a live recording on the Augurari label.

Eric Fredericksen is a curator and writer living in Seattle. He was the director of Western Bridge, Seattle, from 2003 to 2012.

He is currently managing art projects for Waterfront Seattle, a twenty-six block redevelopment of the Elliott Bay waterfront, and teaches at the University of Washington School of Art.

Daniel Fuller is the director of the Institute of Contemporary Art at Maine College of Art, Portland, and is the codirector of Publication Studio, Portland (Other). Fuller came to Maine from the Philadelphia Exhibitions Initiative, a program of The Pew Center for Arts & Heritage. Previously, he was the assistant curator and curator of new media at the Hudson Valley Center for Contemporary Art in Peekskill, New York. He has contributed writing to *Art in America, Art:21, Afterall, ArtAsiaPacific*, and *Art on Paper*.

Lance Fung has been curating large-scale public-art exhibitions for decades, and his most recent project will take place in Atlantic City, where he hopes to attract locals and art enthusiasts alike to experience art in "green" settings. Fung has curated such internationally recognized exhibitions as "Lucky Number Seven," for the 7th SITE Santa Fe International Biennial, and "Wonderland." He has also created exhibitions such as "Crossing

Parallels," at the SSamzie Space in Seoul; "Going Home," at the Edward Hopper House Art Center in Nyack, New York; "Revisiting Gordon Matta-Clark," at Next: The Venice Architectural Biennale; "The Ship of Tolerance by Ilya and Emilia Kabakov," in Siwa, Egypt; "The Snow Show: Venice," at the 50th Venice Biennale; and "Dreams and Conflicts—Dictatorship of the Viewer," in Venice. Fung is also developing a cultural village in Bali, as well as "Sink," an exhibition about marine conservation.

Cesar Garcia is the founding director and chief curator of the Mistake Room—a new independent contemporary-art space in Los Angeles that supports and presents the work of artists and writers living and working outside the United States. From 2007 to 2012, he served as the associate director and senior curator at LA><ART, Los Angeles. Since January 2012, he has served as the United States Commissioner for the 13th International Cairo Biennale.

Rita Gonzalez is associate curator in the Department of Contemporary Art at the Los Angeles County Museum of Art. She is a visiting faculty in the Masters of Public Art Studies: Art/Curatorial Practices in

the Public Sphere program at the University of Southern California's Roski School of Fine Arts. She recently cocurated the exhibition "Asco: Elite of the Obscure, A Retrospective 1972–1987" with C. Ondine Chavoya.

Jennifer Gross is the Seymour H. Knox, Jr., Curator of Modern and Contemporary Art at the Yale University Art Gallery, New Haven, Connecticut. She recently organized a retrospective on American artist Richard Artschwager at the Whitney Museum of American Art, New York, and "The Société Anonyme: Modernism for America," at Yale. Gross is a visiting critic at the Yale School of Art. She earned her PhD from the Graduate Center, City University of New York. She has written on and worked with such contemporary artists as Janine Antoni, Kristin Baker, Mingwei Lee, Josiah McElheny, Thomas Nozkowski, Jim Nutt, Laura Owens, Richard Tuttle, and Rachel Whiteread.

Andrea Grover is a curator, artist, and writer. She is the founder of Aurora Picture Show, Houston, and has curated exhibitions on art, technology, and collectivity for Apexart, New York, and Miller Gallery at Carnegie Mellon University. She

is a coauthor of *New Art/Science Affinities* and is presently curator of programs at Parrish Art Museum, Water Mill, New York.

Pablo Helguera is a New York–based artist in the emerging field of socially engaged art, particularly in the way in which artists incorporate ideas about education and performance in their work. He has published more than ten books, exhibited internationally, and received many awards, including the Guggenheim Fellowship and the Creative Capital Grant. He is director of adult and academic programs in the Education Department of the Museum of Modern Art.

Jens Hoffmann is the deputy director at the Jewish Museum in New York. From 2007 to 2012, he was the director of the Wattis Institute for Contemporary Arts at California College of the Arts in San Francisco. Prior to that, he was the director of exhibitions at the Institute of Contemporary Arts in London. He has curated over three dozen exhibitions internationally since the late 1990s.

Stuart Horodner is the artistic director of the Atlanta Contemporary Art Center. Trained as an artist, Horodner has held director and curator positions at the Atlanta College of Art; Portland Institute for Contemporary Art in Portland, Oregon; and Bucknell University in Lewisburg, Pennsylvania. From 1992 to 1996, he was co-owner and director of the Horodner Romley Gallery in New York City. He has contributed art writing to publications including *BOMB*, *Sculpture*, *Art Lies*, *Art on Paper*, *Surface*, and *Dazed & Confused*.

Hou Hanru has curated and cocurated more than a hundred exhibitions over the last two decades, including "Zizhiqu—Autonomous Regions," Times Museum, Guangzhou (2013); "By Day, By Night, or Some (Special) Things a Museum Can Do," Rockbund Art Museum, Shanghai (2010); the 10th Biennale de Lyon (2009); the 10th Istanbul Biennial (2007); the Chinese Pavilion at the 52nd Venice Biennale (2007); the 4th Gwangju Biennale (2002); and "Cities on the Move" (1997–2000). From 2006 to 2012, he was director of exhibitions and public programs at the Walter and McBean Galleries, San Francisco Art Institute. He received degrees from the Central Academy of Fine Arts in Beijing in the 1980s and moved in 1990 from China to France, where he lived for sixteen years.

Ruba Katrib is curator at Sculpture Center in Long Island City, New York.

Paula Marincola is the first executive director of The Pew Center for Arts & Heritage and the director of its exhibitions program. In the late 1980s and early 1990s, she was director of the Beaver College (now Arcadia University) Art Gallery, where she curated exhibitions of the work of Jennifer Bolande, Felix Gonzalez-Torres, Mary Heilmann, Ken Price, Richard Prince, Fred Wilson, and others. Several years ago, she began research on an anthology on formal and structural innovation in exhibition making since the 1960s, which she is now coediting with Peter Nesbett.

Sarah McEneaney born 1955 in Munich, attended the University of the Arts and the Pennsylvania Academy of the Fine Arts in Philadelphia. McEneaney's paintings and prints are in many public collections, including the Philadelphia Museum of Art, the Pennsylvania Academy of the Fine Arts, the Neuberger Museum of Art, Rhode Island School of Design, Johnson and Johnson, and Microsoft Corporation. Awards received by McEneaney include an Anonymous Was a Woman Grant, a Joan Mitchell Foundation Grant, a Pew Fellowship in the Arts, and residencies at Chinati Foundation, Fundación Valparaiso, MacDowell Colony, and Yaddo. McEneaney lives and works in Philadelphia and is represented by the Tibor de Nagy Gallery, New York, and Locks Gallery, Philadelphia.

Lisa Melandri is the director of the Contemporary Art Museum, St. Louis. Previously, she was the deputy director for exhibitions and programs at Santa Monica Museum of Art. Recent projects include "Mickalene Thomas: Origin of the Universe," "Beatrice Wood: Career Woman," and "Marco Brambilla: The Dark Lining."

Helen Molesworth is the Barbara Lee Chief Curator at the Institute of Contemporary Art (ICA) Boston, where she has organized one-person exhibitions by artists Catherine Opie and Josiah McElheny and group exhibitions, such as "Dance/ Draw" and "This Will Have Been: Art, Love & Politics in the 1980s." While head of the Department of Modern and Contemporary Art at the Harvard Art Museum, she presented an exhibition of photographs by Moyra Davey and "ACT UP NY: Activism, Art, and the AIDS Crisis 1987–1993." She is the author

of numerous catalogue essays, and her writing has appeared in publications such as *Artforum*, *Art Journal*, *Documents*, and *October*. The recipient of the 2011 Bard Center for Curatorial Studies Award for Curatorial Excellence, she is currently at work on the first museum survey exhibition of painter Amy Sillman.

Jessica Morgan is the Daskalopoulos Curator, International Art, at Tate Modern, London.

Aram Moshayedi is a writer and the assistant curator of the Gallery at REDCAT in Los Angeles, where he has recently produced exhibitions with Geoffrey Farmer, Erlea Maneros Zabala, and Ming Wong. He has contributed to numerous exhibition catalogues and has written for *Artforum*, *Metropolis M*, *Art in America*, *Reading Room: A Journal of Art and Culture*, and *Art Papers*. He also serves on the editorial board of *X-TRA Contemporary Art Quarterly* and is a contributing editor for *Bidoun*.

Peter Nesbett is research strategist and senior specialist in exhibitions at The Pew Center for Arts & Heritage. From 2001 to 2010, he and Shelly Bancroft codirected Triple Candie's gallery in Harlem.

He is a coeditor of the two-volume *The Complete Jacob Lawrence*, as well as *Diaries of a Young Artist*, and *Letters to a Young Artist*. With Paula Marincola, he is coediting an anthology on formal and structural innovation in exhibition making since the 1960s.

Valerie Cassel Oliver is senior curator at the Contemporary Arts Museum Houston, where she has worked since 2000. She has organized numerous exhibitions that have earned national and international acclaim including "Double Consciousness: Black Conceptual Art since 1970" (2005); with Andrea Barnwell Brownlee, "Cinema Remixed and Reloaded: Black Women Artists and the Moving Image," which was nominated for an International Association of Art Critics Award and presented at the 11th Havana Biennial in 2012; the retrospective "Benjamin Patterson: In the State of Flux/us"; and the 2011 survey "Donald Moffett: The Extravagant Vein" (2011). Most recently, she organized a posthumous survey of photographs by Alvin Baltrop titled "Dreams into Glass"; and "Radical Presence: Black Performance in Contemporary Art," an exhibition that chronicles the history of black performance in the visual arts from the 1960s to the present.

Jenifer Papararo is curator of the Contemporary Art Gallery, Vancouver, and a founding member of the curatorial and artist collective Instant Coffee.

Daniela Pérez is an independent curator based in Mexico City. She completed the MA in curating contemporary art at the Royal College of Art and has worked at institutions including Museo Tamayo, Mexico City; Museu de Arte Moderna, São Paulo; New Museum, New York; and Museo de Arte Carrillo Gil, Mexico City. She is cofounder of de_sitio, a new platform that conceptualizes, develops, and promotes contemporary-art projects, seeking to collaborate with organizations and individuals from diverse contexts; focusing on process, de_sitio is a flexible and critical space that enables dialogue.

Ralph Rugoff is director of the Hayward Gallery at the Southbank Centre in London. He recently curated "George Condo: Mental States" and "Jeremy Deller: Joy in People," both of which traveled internationally.

Ingrid Schaffner is senior curator at the Institute of Contemporary Art, University of Pennsylvania, where she has organized monographic exhibitions of the work of artists Douglas Blau, Karen Kilimnik, Barry Le Va, and Polly Apfelbaum, architect Anne Tyng, and illustrator Maira Kalman, as well as group exhibitions, including "Dirt On Delight: Impulses That Form Clay," "The Puppet Show," "Queer Voice," and "The Photogenic." As an independent curator, she organized the exhibitions "Deep Storage: Collecting, Storing, and Archiving in Art," "Julien Levy: Portrait of an Art Gallery," and "Gloria: Another Look at Feminist Art of the 1970s." She is currently working on a survey exhibition of the work of Jason Rhoades.

Chief curator of the Museum of Contemporary Art, Los Angeles, from 1990 to 2012, **Paul Schimmel** has organized more than fifty-two exhibitions, many of which have traveled to major institutions, including the Metropolitan Museum of Art, New York; Centre Georges Pompidou, Paris; National Gallery, Washington, DC; Museum of Contemporary Art, Tokyo; Museum of Contemporary Art, Chicago; Whitney Museum of American Art, New York; and the Walker Art Center, Minneapolis. He has served as a National Endowment for the Arts panelist and currently serves as a member of the Clyfford Still

Museum Advisory Committee, the Contemporary Art Collection Acquisition Committee for the Fundació "la Caixa," and as a member of the Committee for the Preservation of the White House.

Sarah Robayo Sheridan has recently been appointed to the position of curator of exhibitions at the Power Plant, Toronto. She is active as an arts writer and serves as a sessional lecturer in the Department of Visual Studies at the University of Toronto at Mississauga. She holds an MA in curatorial practice from the California College of the Arts.

Elizabeth Smith joined the Art Gallery of Ontario in Toronto as executive director of curatorial affairs, in 2010. Previously she was chief curator and deputy director for programs at Chicago's Museum of Contemporary Art and was curator at the Museum of Contemporary Art in Los Angeles. Smith has taught at the University of Southern California and the School of the Art Institute of Chicago and is a trustee of the Graham Foundation for Advanced Studies in the Fine Arts. She was recently a 2012 Fellow of the New York–based Center for Curatorial Leadership.

Robert Storr is an artist and critic who, since 2006, has been the dean of the School of Art at Yale University, New Haven, Connecticut. He was the commissioner of the 2007 Venice Biennale and, from 1990 to 2002, curator in the Department of Painting and Sculpture at the Museum of Modern Art, New York. He continues to curate independently.

Astria Suparak is currently the director and curator of Carnegie Mellon University's Miller Gallery, in Pittsburgh, where she curated the internationally touring Yes Men retrospective, "Keep It Slick: Infiltrating Capitalism with the Yes Men," organized the Contestational Cartographies Symposium, and cocurated the exhibitions "Whatever It Takes: Steelers Fan Collections, Rituals, and Obsessions" and the 2011 Pittsburgh Biennial. She recently edited *The Yes Men Activity Book* and coproduced *New Art/Science Affinities*.

Claire Tancons is a New Orleans–based curator, researcher, and writer who focuses on public ceremonial culture, processional performance, and popular movements. She was the associate curator for Prospect.1 New Orleans, a curator for the 7th Gwangju

Biennale, and a guest curator for CAPE09. Upcoming projects will take place in the United States, Sweden, Benin, and Trinidad. She is based in New Orleans and works in situ.

Since January 2007, **Nato Thompson** has been chief curator at Creative Time, New York, organizing projects such as "Democracy in America: The National Campaign," Paul Chan's acclaimed *Waiting for Godot in New Orleans*, and Mike Nelson's *A Psychic Vacuum*. Prior to Creative Time, he worked as curator at MASS MoCA.

Gilbert Vicario is senior curator at the Des Moines Art Center in Iowa. Recent exhibitions include "Miguel Angel Ríos: Walkabout" (with contributions by Raphael Rubinstein, Julieta Gonzalez, and Osvaldo Sanchez in the accompanying publication) and "Dario Robleto: Survival Does Not Lie in the Heavens" (with contributions by Naomi Oreskes and Michelle White in the accompanying publication).

Namita Gupta Wiggers is the director and chief curator of the Museum of Contemporary Craft (in partnership with Pacific North-west College of Art), Portland, Oregon. Wiggers has led curatorial programming there since 2004, organizing such exhibitions as "New Embroidery: Not Your Grandma's Doily," "Touching Warms the Art," "The Academy Is Full of Craft," "Call + Response," "Manufractured: The Conspicuous Transformation of Everyday Objects" (curated by Steven Skov Holt and Mara Holt Skov), and "Gestures of Resistance" (curated by Shannon Stratton and Judith Leemann). She curated the first museum exhibitions to focus on Laurie Herrick, Nikki McClure, Ken Shores, Emily Pilloton, and the collaboration of Andy Paiko and Ethan Rose "Transference." Wiggers is the author of *Generations: Betty Feves* (2012), *Unpacking the Collection: Selections from the Museum of Contemporary Craft* (2008), and editor of Garth Clark's *How Envy Killed the Crafts Movement: An Autopsy in Two Parts* (2009). She cofounded Critical Craft Forum and serves on the Board of Trustees of the American Craft Council.

ACKNOWLEDGMENTS

The editors are grateful for the generous contributions of everyone involved with this publication. We would first and foremost like to express our deep gratitude to the forty-three curators who agreed to answer our pigeonnaire—taking time out of their busy lives to be interviewed about their practices and the field, and providing such valuable responses. Transcripts of these full interviews can be found on The Pew Center for Arts & Heritage's website (www.pcah.us).

We would also like to thank artist Sarah McEneaney, a 1993 Pew Fellow, who embraced our from-left-field request for pigeon drawings with amusement and gusto, taking to Philadelphia's public parks for inspiration. We think that the pigeon portraits she captured on her sojourns are quirky, full of personality, and deeply affecting. They add immeasurably to the book's appeal. (Note: Any similarities in appearance between her pigeons and the curators who contributed to the book are purely coincidental.) Karen Kelly, of Dancing Foxes Press, has been a delight to work with; she is a knowledgable collaborator who has handled copyediting and production with grace and good humor. She also introduced us to Leftloft, designers Francesco Cavalli and Krishna Fitzpatrick, who are responsible for the book's playful but elegant design. It's been a pleasure to have worked with such a talented design team. Paula Marincola would also like to acknowledge Peter Nesbett's great creativity and industry in bringing these pigeons to roost within the pages of this book. Finally, we'd like to thank our funder, The Pew Charitable Trusts, who makes our work possible, and our colleagues at The Pew Center for Arts & Heritage, particularly Nicole Steinberg.

To order, call 267.350.4900, or email info@pcah.us.

ABOUT THE PEW CENTER FOR ARTS & HERITAGE

The Pew Center for Arts & Heritage (the Center), established in 2005, is a multidisciplinary grantmaker, dedicated to stimulating a vibrant cultural community in the five-county Southeastern Pennsylvania region. The Center supports area artists and organizations whose work is distinguished by excellence, imagination, and courage. Each year, these grants make possible several hundred performing arts events, as well as history and visual arts exhibitions and other public programs for audiences in Philadelphia and its surrounding counties. Beyond its work as a unique and exemplary grant-maker in the arts, the Center is also a hub for the discussion and exchange of ideas concerning artistic expression, cultural interpretation, and audience engagement, organizing and presenting a lively host of activities that aim to build programmatic and management capacity among constituents. Highlights of Center professional development events include trips, symposia, lectures, reading groups, master classes, and workshops. The Center also commissions and publishes scholarship and research on issues that grow directly out of our experience funding cultural practice.

The Center (www.pcah.us) is funded by The Pew Charitable Trusts (www.pewtrusts.org) and administered by The University of the Arts, Philadelphia (www.uarts.edu).

PUBLISHED BY THE PEW CENTER FOR ARTS & HERITAGE

TEXT
© 2013 The Pew Center for Arts & Heritage

DRAWINGS
© 2012 Sarah McEneaney

ISBN
978-0-9887109-0-0

LIBRARY OF CONGRESS CONTROL NUMBER
2012955756

EDITORS
Paula Marincola and Peter Nesbett

EDITORIAL MANAGEMENT
Karen Kelly

PROOFREADER
Polly Watson

DESIGN
Leftloft, Milan and New York

PRINTED AND BOUND BY
Capital Offset, Hollis, New Hampshire

PRINTED IN
the United States of America

For the full-text interviews from which this book was made, please visit www.pcah.us.

THE PEW CENTER FOR ARTS & HERITAGE
1608 Walnut Street, 18th Floor
Philadelphia, PA 19103
www.pcah.us